Horst Keller

Monet's Years at Giverny
A Garden becomes Painting

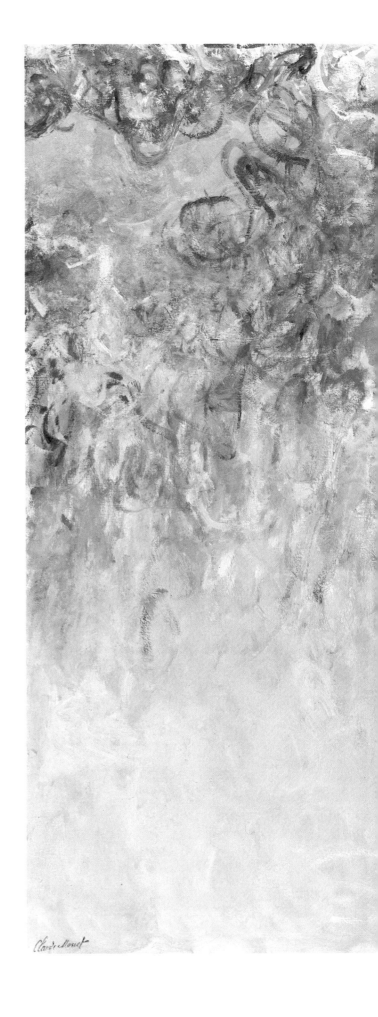

'Rien au monde m'intéresse
que ma peinture et mes fleurs.'

*Wysteria. Ca 1920–25*

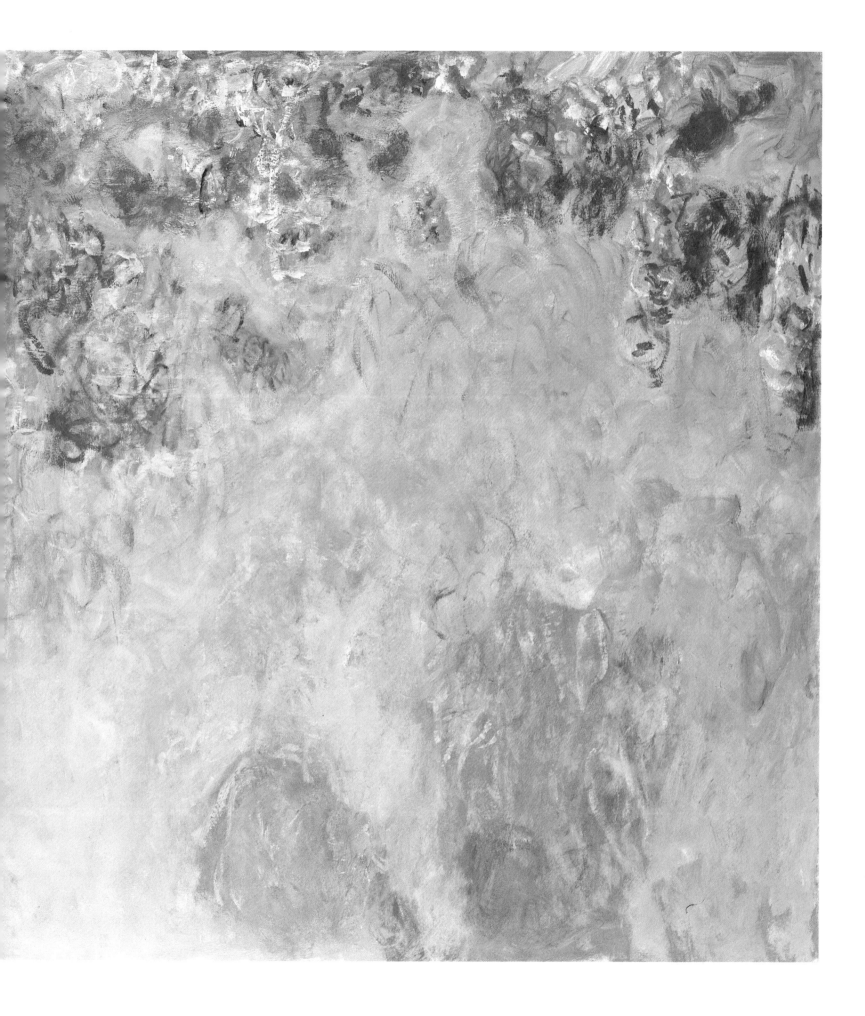

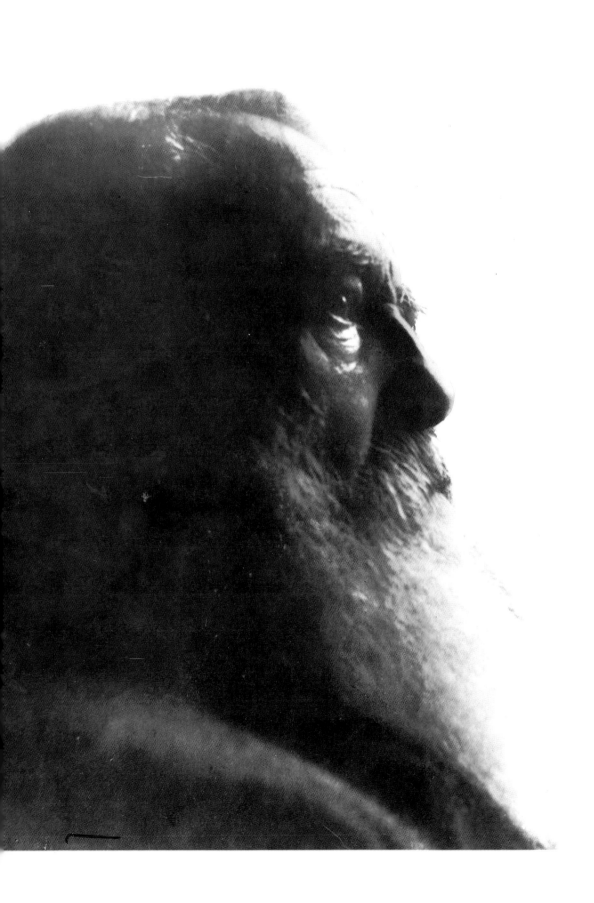

*Claude Monet at Giverny,*
*ca 1915.*
*Collection Roger-Viollet, Paris*

# Horst Keller

# Monet's Years at Giverny
# A Garden Becomes Painting

With a contribution by

Herbert Keller

DUMONT
monte

Cover illustration front: Path in Monet's Garden at Giverny. 1902
(Detail; cf colour plate p 80)
Cover illustration back: Banks of the Seine at Vétheuil. 1880
(cf colour plate p 50/51)

© 2001 DuMont Buchverlag, Köln
(Dumont monte UK, London)

Translation Sylvia Gouding; Editor Susan Churchill;
Layout Norma Martin; Project Management Sylvia Goulding, Silva Editions

Printing: Rasch, Bramsche
Bookbinders: Bramscher Buchbinder Betriebe

ISBN 3-7701-7090-3

# Contents

# Colour plates

*Note:* All reproductions of Claude Monet's paintings are in colour and have been compared with the originals for faithful reproduction of colour; photographs taken during Monet's life are two-colour – in duotone reproduction, photographs taken in recent years and cited paintings are reproduced in black and white.

# A painter's garden restored to life

He kept a tight rein on nature, albeit a golden rein, but he was firmly resolved to make nature subservient to his artistic vision. This is the impression we have when we think of Monet's summer gardens in Giverny, gardens 'for painting'.

The pale, narrow leaves shed by the weeping willow and now resting in between the plate-like leaves and calyxes of the water lilies are easy to discern from the delicately arched, wisteria-cloaked Japanese bridge. During the painter's lifetime, just 75 years ago, his gardener's punt would drift across the pond every morning at dawn to remove all that might perturb the calm beauty of the water lilies and the water, and the perfect reflection of the skies. Today, Monet's 'reins' are hardly noticeable here any more, despite the busy activity of the gardeners in this memorial garden.

There is a photograph of the water lily pond, decades old, taken in the days when it was still lost in deep oblivion. It depicts a young man with his boat amid veritable carpets of water lilies. He is loading the plants he has pulled out of the water into his boat, in a vain attempt to gain the upper hand in this wilderness. This image is far removed from the reality today – Monet's garden has risen from its fairy-tale slumber, roused by the veneration of the artist, the painter of the water lilies and irises, rose arches and tuberoses. Only recently have the house and garden been freed from the patina of history, and now they breathe again. The pond is surrounded by flowers, the paths are kept clear, Monet's colours and flowers dominate the picture once more – as if the painter had again put his hand to this the most beautiful of painterly gardens known to us.

Today, of course, there are only visitors, silent or chattering, who wander through the garden, soon to leave it again. They cannot be called 'guests' in Monet's sense of the word, these visitors who glance only casually at what one leaflet described as the *source d'inspiration du grand peintre* (source of inspiration for this great painter); at one time this garden was a place of contemplation. At night the long house, with its numerous windows facing south and overlooking the garden, and its colours – pink, white and a bold

green – restored, fades into stillness, waiting for the new morning, like all things that give life yet live in the memory. This is the *Musée Claude Monet*.

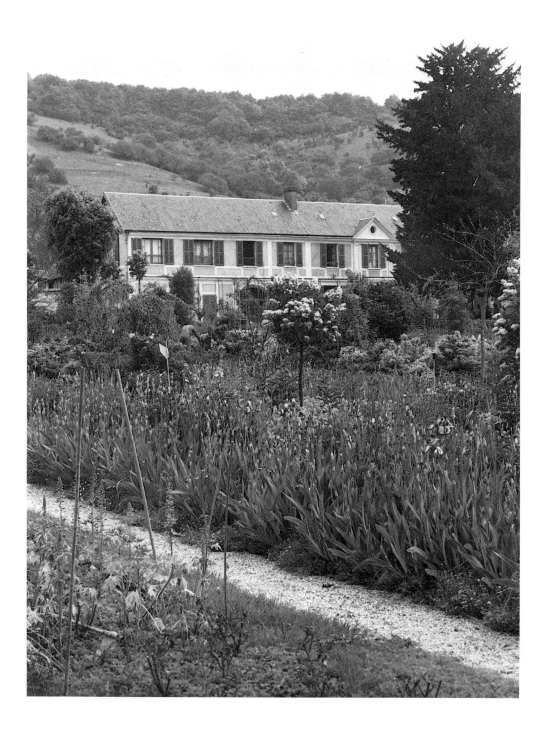

*Monet's house and garden in Giverny. Musée Claude Monet, Giverny. Collection Roger-Viollet, Paris*

# Monet discovers Giverny

Monet is already in his forties when he discovers Giverny for himself. He has made his home at many a place between Paris and the Normandy coast, always close to the water and especially on the Seine, which attracts him throughout his life. In his studio-boat, which he has owned since his days at Argenteuil, he paints between trees and shrubs, in sunshine and in rain, humble-and-happy yet also desperately poor. Camille, to whom he has devoted many paintings that have since become famous, has died. Together with his two sons as well as Alice Hoschedé and her six children – a situation we will return to later – he lives in cramped conditions, in small, modest houses in Vétheuil and Poissy, his feet almost dangling in the waters of the Seine, which continuously bursts its banks.

*Illus. p 76*

Thus he roams across flood plains and adjacent hills, a landscape of water meadows, small copses and villages that has provided creative inspiration to so many of his Impressionist painter friends. He always stays close to the river, with its islands and side channels, its bays and sand banks, meandering gently and infinitely slowly from the boggy lowlands to the sea. The Seine, undisturbed then by subsequent canalisation, is only navigable at peril; for the boatman, however, it is a genuine paradise.

Huffing and puffing, at the leisurely pace typical of most mechanical movement a hundred years ago despite the celebration of progress, the railway carries the painter from Gisors, on the upper reaches of the modest Epte river, which was to become so important for Monet's plans, towards Vernon, on the eastern rim of the *Vexin Normand*, the large granary with corn fields stretching from one horizon to the other. The route snakes along below white rocks and abandoned vineyards towards the Seine, which embraces the Epte and its smaller, watery branches traversing the meadows and invites them into its lazy riverbed.

And here, after travelling past many a picturesque spot that decorates the landscape and towers above it, Monet spies the village where he can stay, not just for a short time nor only to paint, but for the remaining decades of his life while he is still able to paint. It is spring in the year 1883.

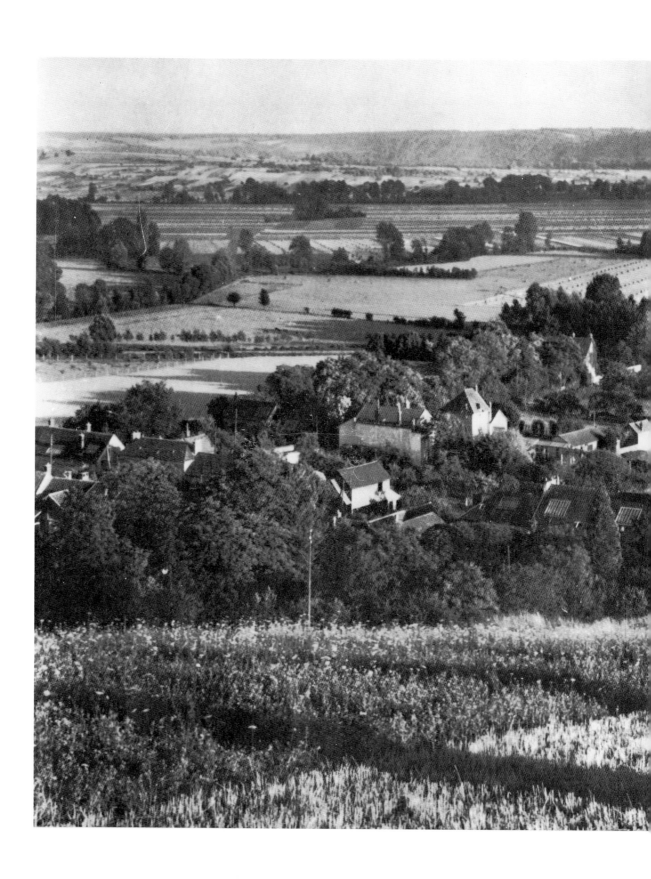

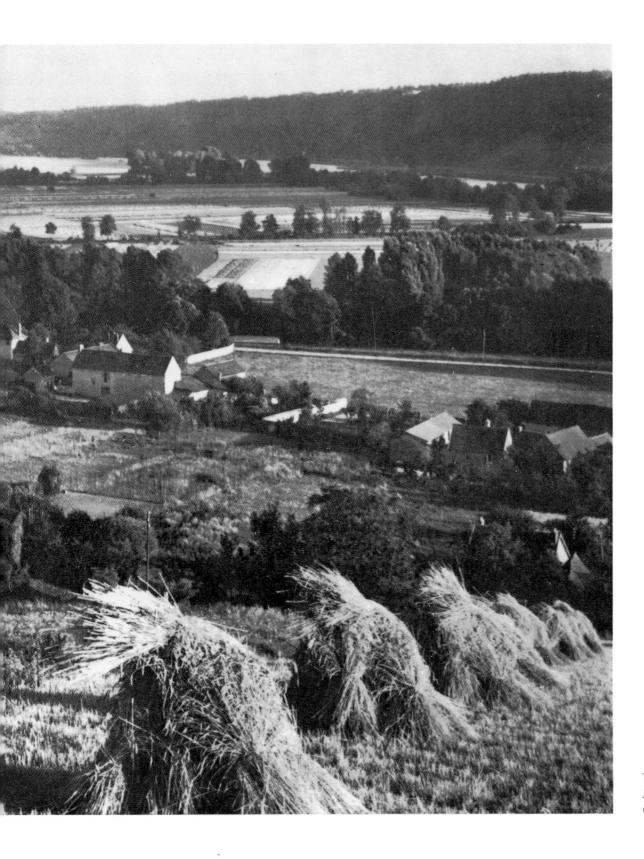

*The village of Giverny during Monet's lifetime. Collection Country Life Magazine*

## *The dream landscape*

Giverny is a tiny village on the water's edge, surrounded by swamps and meadows and set into a hill that gently slopes to the south. From Mont Croquet, the impressive hilltop, woods and shrubs fall away to the plain and the edge of the few cultivated fields. In earlier times vines were also grown here, which is why Monet's future realm is also known locally as *Le Pressoir* (the winepress).

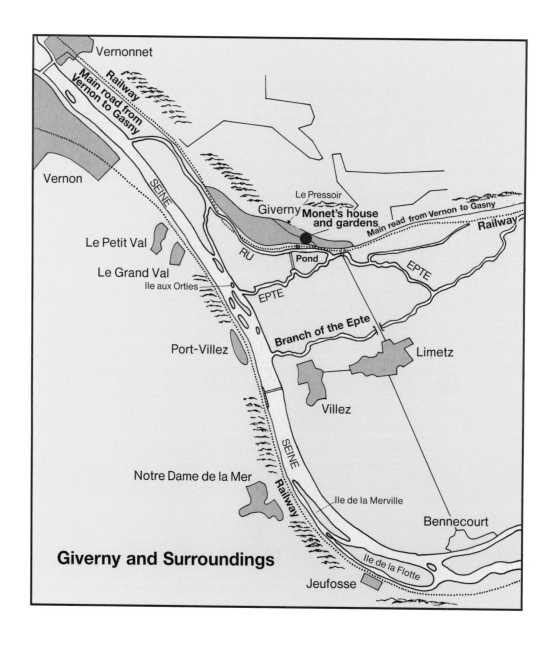

**Giverny and Surroundings**

By the time he has walked down the two dusty streets in Giverny, the upper road – today named after the artist – and the slightly lower road, which are connected only by a few steep alleyways marked by rivulets created by the rain, his future home has already been chosen. There are but a few homes inhabited by farmers, who – rather affectedly – call themselves *cultivants* yet have nothing much else on their minds than the price of cattle and a good harvest of hay.

## The village

The Normandy village of Giverny was still ignorant of and uninterested in its future fame, but its landscapes would nevertheless reach the remotest corners of the world once they had been transformed into works of art by Monet. They reached much farther and were much more accessible than the *hameaux*, those villages and hamlets where a quarter of a century earlier an awkward doctor was made to practise his craft, unaware of the eccentric traits and needs of his *Madame Bovary*, when in Croisset Castle the writer Gustave Flaubert wrote about Rouen. Of course, Monet's Giverny, with its beggars and 'characters', its troublemakers and small-scale schemers and plotters, could equally well have supplied sufficient material for Flaubert's most famous novel.

*Illus. pp 14/15*

The painter, who has an eye for gardens, makes a deal with a man who, on his return from Guadeloupe, had retired here, to a long, narrow house with a large fruit orchard that gently slopes towards the *marais* (the swamp), the River Epte and the little Ru stream.

The large family modestly, almost unbelievably easily, moves into their new abode, with their few possessions, which are carried down the River Seine to a point fairly close to the house in a houseboat. Only Monet, who is experienced on the water, could dare such an undertaking. Like anything else demanding quiet determination, it deserves our admiration, even more perhaps than the many hundreds of pictures that he creates here in the decades between 1883 and 1926.

Monet has to break down a thunderous wall of rejection and animosity, has to bear lesser and greater vitriol. His cheerful family disrupts the peace of the village, where the picture, the painted canvas, is unknown, and where the

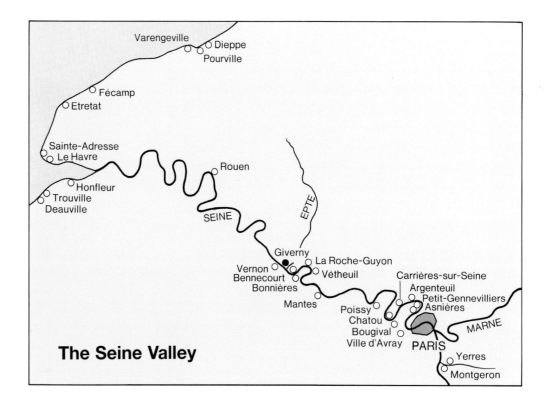

**The Seine Valley**

lifestyle and ideas of a gardener who grows neither cereals nor vegetables but flowers, and only flowers, are regarded as those of the devil. He is a foreign apparition for the people in their peasant garb, their berets askew, who bake their own bread and eat meat only on Sundays. The painter, who has spent the hard years of his childhood and youth on the Normandy coast at Sainte-Adresse, just outside Le Havre on the mouth of the Seine, enduring his parents' lack of comprehension, suffers much gloom in his strife for recognition, yet here he finds a paradise for his energy. For Monet, who has been ready to end his life out of sheer desperation more than once, to whom the salons of Paris offer only fleeting moments of success in exhibitions, whose companion fighters, the Impressionists, scramble all over Provence, Giverny at last becomes a place of rest.

His determination, overwhelming for others and even for him, to stay, to perfect his idea of painting light *en plein air*, at the same time necessarily brings about a turning point in his life; in his robust nature, too, which is unusually free from susceptibility, it pirtends change. And in fact he succeeds in transforming the gardens at Giverny into his very own chapter of European art history, characterised by a wonderful and lasting magic that still enchants visitors today.

On the day that he is moving into *Le Pressoir*, Monet finds out about the death of his friend Manet. This horrifying news plunges everything into confusion, demanding Monet's sympathy and a hurried journey to Paris, which brings alarming disruption to a daring artistic and horticultural enterprise. Notwithstanding this, nor his painful realisation of how many an artistic hope is dashed, he responds full of unbroken vigour.

Even as he commences the patient transformation of the *Clos Normand* (*clos* is the French term for a fenced field), the Norman cottage garden with its forlorn fruit trees, into an incomparable and unforgettable 'Monet garden', he nevertheless untiringly promotes a petition in Paris to have Edouard Manet's chief work, 'Olympia', accepted by the Louvre, in order to help Manet's grieving widow.

Thanks to the persistence that was probably the main trait of his character he is successful in both these undertakings.

*Monet ca 1883. Collection Roger-Viollet, Paris*

## *Le Pressoir*

The estate in Giverny is just what Monet was looking for; the landscape, the light above the plains, the neighbouring ridge that bounded the property not too far away, the fact that it was easy to overlook. Here he can put down his roots. As has often been told – more often than not inaccurately and embellished with anecdotes – he digs and weeds, together with his family and with great effort, in his fruit orchard, watched closely by spiteful glances over the wall. He plants and lets blossom, but leaves the evergreens to wither away. His 'floral imagination' creates a world of plants that spans the entire year and – with the help of his friend, the painter Caillebotte[1], an experienced hobby-gardener – even several years.

[1] Gustave Caillebotte (1848 Paris–1894 *ibidem*), French painter and patron of the French Impressionists

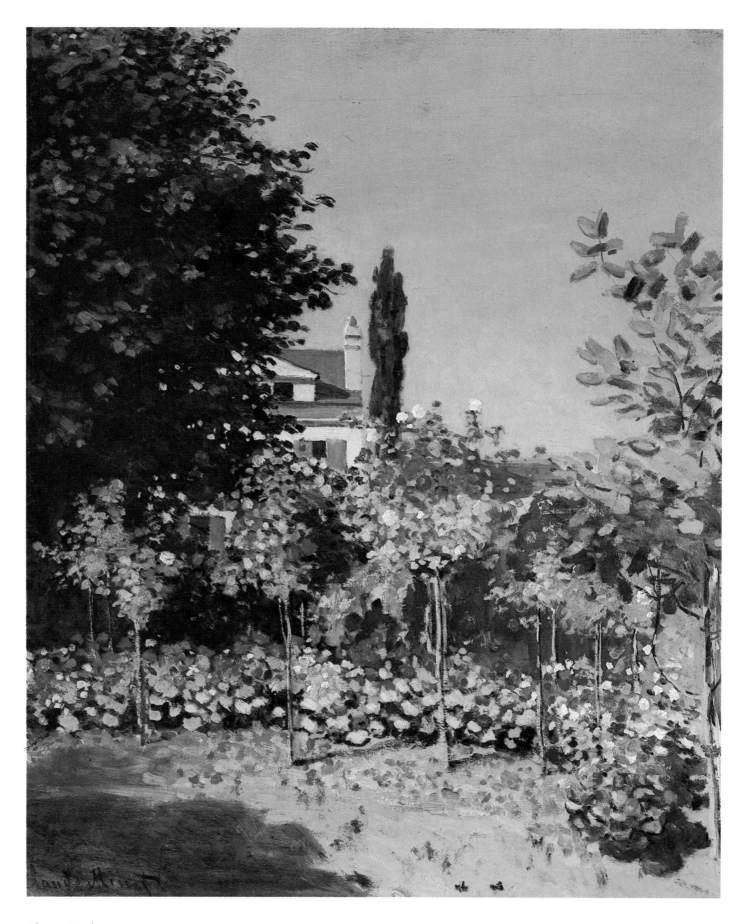

*Flower Garden. Ca 1866*

A sublime slowness takes hold of him. He calculates only in expanses of time, although in his painting he elevates the moment to the highest rank, the half hour during which the light remains comparable in intensity or rests on an object with a comparable degree of refraction; on the haystacks, on the rows of poplars which accompany the Epte on its meandering course, on the blossoming garden.

The village greets the changes at *Le Pressoir* with surprise and disapproval, its unaccustomed 'painterly' design lacking a green labyrinth, lacking grottoes, but most of all lacking any useful purpose. Instead, the *Clos Normand* develops a controlled colourfulness that soon banishes all wild riots of colour as well as any rampant growth.

Here, Monet becomes a horticultural artist, the lord of a realm which obeys the simple laws of sun, rain and storm, of flowering and fading. He participates in this giant game of patience, and his entire circle does so with him; nature calms, appeases, soothes unruliness.

The *cultivants* (as the neighbouring farmers call themselves) cannot understand this. Maeterlinck[2] said in his essay on *Ancient Plants*: 'The gardens of our forefathers were still almost barren. Man had not yet understood how to look around himself and to participate in the enjoyment of the life of nature.' As if coined for these Norman farmers, Egon Friedell[3] adds, quoting this sentence so remarkably appropriate in the context: '...this is easy to understand: Man was unable to see nature because he himself was still part of it.' And when you look at the family, busying themselves in their efforts to conquer the garden, enthusiastically taking in its beauty, then you will also agree with the following sentiment: 'Lyrical enthusiasm for nature can only ever originate in urban cultures.'

[2] Maurice Maeterlinck (1862 Ghent–1949 Nice), Belgian poet

[3] Egon Friedell, *Kulturgeschichte der Neuzeit*, München (1927–32) 1951, vol 3, p 476

## Two families

It is more a living community than a regular family who take possession of the house and garden. To retrace the situation in a few strokes: beautiful Camille Doncieux, once Monet's most famous model and his wife from 1870, had died in 1879, only 32 years old, after the birth of their second son Michel, in nearby Vétheuil. Alice Raingo, who had four daughters and two sons from her marriage to Ernst Hoschedé, had lived with Monet in Vétheuil and cared for his motherless sons. Now she and the eight children move to Giverny. The eldest daughter, Marthe, is almost a young woman; the youngest boys, Michel Monet

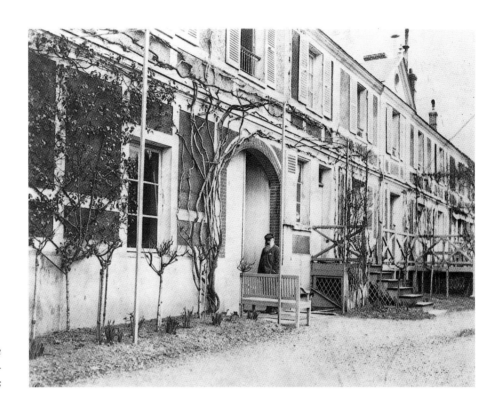

*Monet in front of his house in Giverny. Collection Durand-Ruel, Paris*

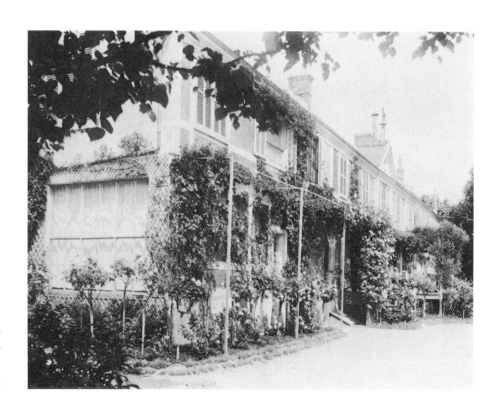

*Climbing roses, clematis and wild vines cloaked the trellises around the house in the summer. Collection Truffaut, Paris*

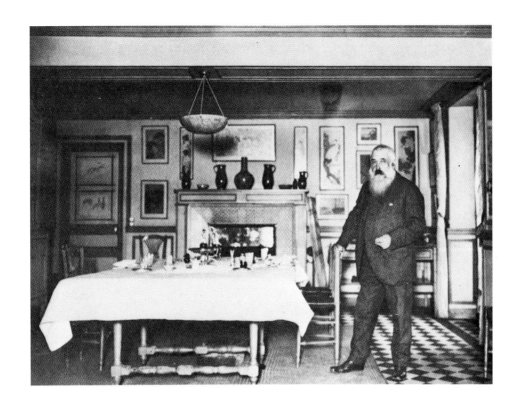

*Monet in his dining room in Giverny, ca 1915; his collection of coloured Japanese woodcuts can be seen on the walls. Collection Piguet, Paris*

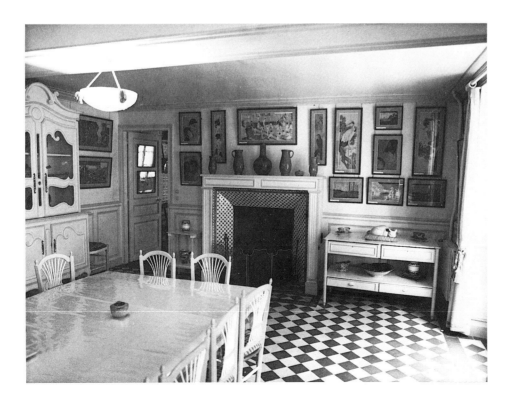

*Monet's dining room after restoration. Musée Claude Monet, Giverny. Collection Roger-Viollet, Paris*

and Jean-Pierre Hoschedé, aged six, become an inseparable duo, roaming the wilderness, ready for the village school. The unfortunate Ernest Hoschedé, once a wealthy financier with a castle and an art collection in Montgeron, a village south of Paris, did not die until 1891, far from Giverny, and so the arrival of the painter with Madame Hoschedé and her offspring was an additional scandal in the village – a never-ending stream of whispers must have been reported back to the Abbé.

For the painter's life and work, for the garden – and soon gardens – for house and home, for all the helpers whom Monet needed – his step-daughter always carried his painting materials, and the children carted his canvases to the meadows near the Seine and the Epte in a wheelbarrow – their arrival, albeit bohemian in character at first, meant sheer happiness, which was to last undiminished until the death of Alice in 1911. Alice married Monet in 1892.

Blanche later married her step-brother Jean Monet, 11 years the senior of little Michel, only to lose him in February 1914 after a dismal disease. Blanche Hoschedé-Monet became the painter's closest confidante and remained so until his final hour. Many photographs show her at his side, smiling patiently, silent and protective, a warm overcoat draped over her arm for the proud, elderly man, together with numerous, ever more famous visitors to Giverny. She is his muse and consolation. The great statesman and Monet's good friend Georges Clemenceau, himself deeply immersed in the late work of the 'Nymphaeum', of the water lilies and weeping willows – and a passionate patron of these giant paintings – called her the 'angel'.

## The house

It is not necessary here to draw a more detailed portrait of this painter's family, who are all finding themselves. The garden is full of life, and it is reasonably easy to imagine their everyday life, the good days and the bad days, when we enter the veranda and the house today: everything is functional and beautiful, just as it was in Monet's time – a masterpiece of restoration[4]. Colourful Japanese woodcuts adorning the walls, which are meant to provide 'a respite from paintings'; the large family table in the yellow dining room; the blue-tiled kitchen where the meals are prepared that made a place at Monet's table so desirable; the small blue salon for Madame; the children's rooms on the upper floor; the view of the garden through the windows in the doors, with small, charmingly low fences.

4 Cf Herbert Keller's article, pp 143 ff

Illus. p 23

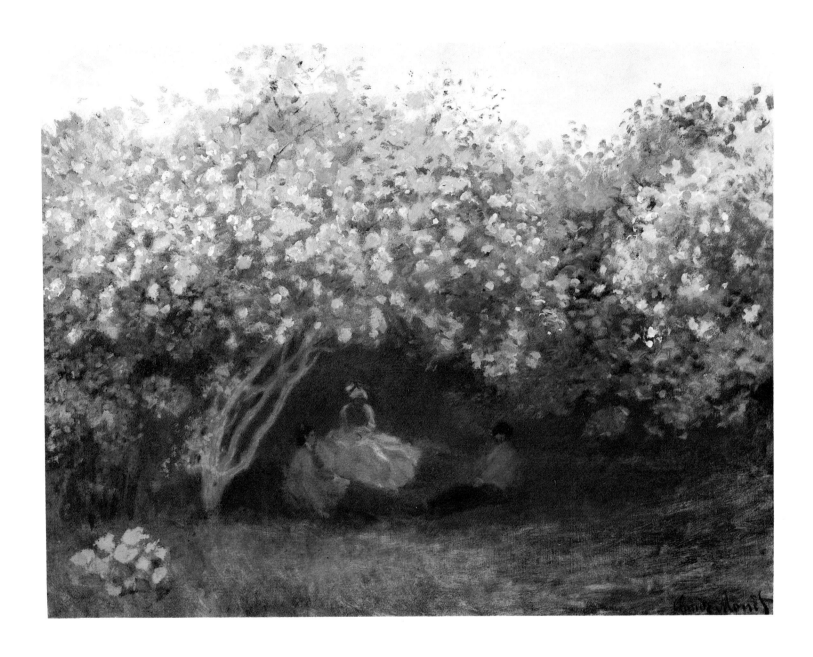

*Lilac. 1872*

Monet carries out his improvements with deliberation. One thing follows another, but only when he has achieved one of his painterly visions, when he is 'actively resting' from painting and from the artistic inspiration that virtually uses him up and depletes his energies.

He has created his own realm: simple and comfortable and without any pretence or the cult of the studio. Craftsmen are earning their crust from him, first those in Giverny and soon, as Monet's wealth increases, those from Vernon as well. He creates his own space where the previous owner once had *Illus. p 30* a carriage shed, on the west wing of the narrow-sided, long house that turns its back on the village street. The first studio, spacious and with a mighty west-facing window, lies lower than the rest of the raised ground floor. An internal staircase connects it with the rest of the house. A settee and bed, a desk, and many armchairs and chairs make this space homely; along the walls, in three rows on top of each other on the narrow shelves are paintings, which at first he shows only to friends – but soon to a few dealers, too. This becomes a custom, and over the years the garden and landscape that he has transformed into paintings are presented to critical eyes for quiet assessment. Yet never the painting that he has just created, still wet; unhappy with himself as ever, these paintings are initially banished from view for a long time.

The silent Norman is difficult in this respect, he wants to be buoyed up, but it takes him an enormous effort to overcome his scepticism of any encouragement and verbose adulation that are proffered, and he wards off all discussions about art and his paintings. In the beginning he still meets regularly with his painter friends in the Café Riche in Paris, which he forces himself to attend. He sits listening while Renoir and Caillebotte persist in their rows and then returns to his perfect solitude and his subjects, which he grants one and at best two 'sessions'.

To finish the portrait of Monet's most personal realm in Giverny, sacred to the family and always respected by them: above the studio, and now on the same level as the other rooms of the upper storey, is his bright bedroom. From the window he has a view of the garden, past the tall, shadow-giving yew trees that he has left standing in front of the centre of the house. The staircase leads up to the terrace that runs along the southern elevation, and the roof space has a neat triangular gable with a 'bull's eye'.

The dark shapes of the mighty yews still form a barrier on the main path of the *Clos Normand*, contrasting strongly with the pink house front. Other evergreen plants that used to fringe the path have retreated from Monet's horticultural cunning: pruned back, they are gently suffocated by the roses he allows to clamber all over them.

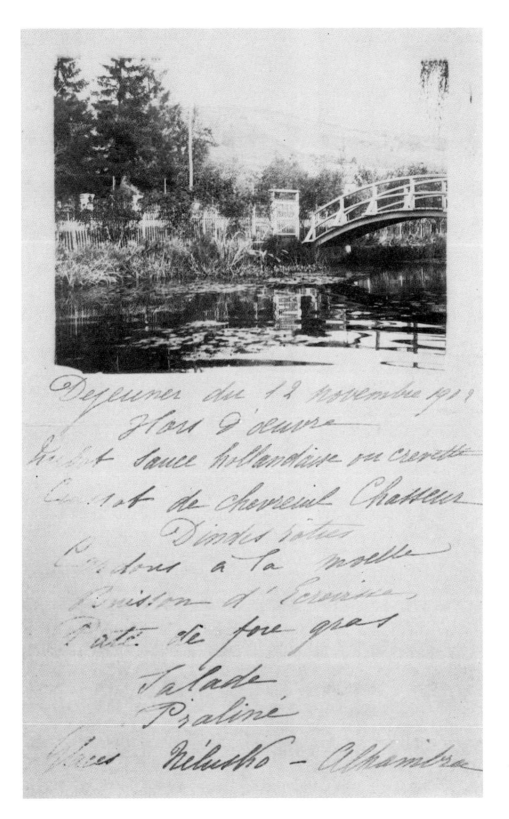

*Déjeuner on 12 November, 1902, on the occasion of the wedding of Monet's youngest step-daughter, Germaine Hoschedé, and Albert Salerou. Collection Piguet, Paris*

'The subject is of secondary importance for me: I want to represent what lives between the object and me.'

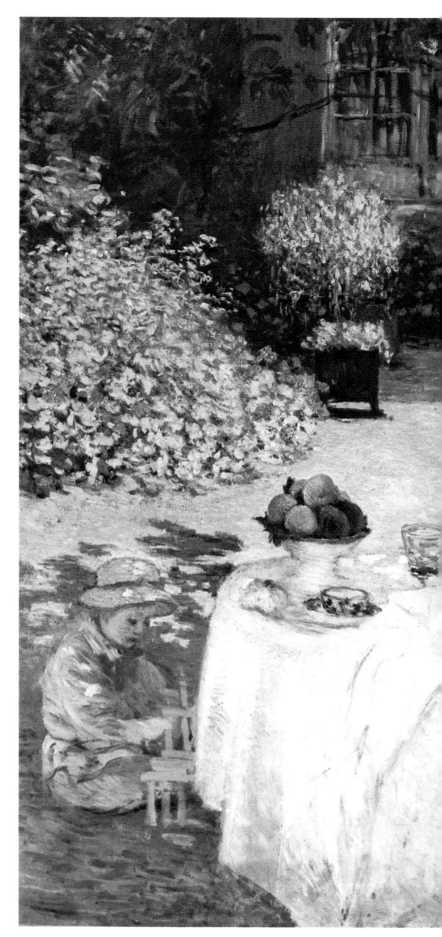

*The Luncheon. Ca 1873–74*

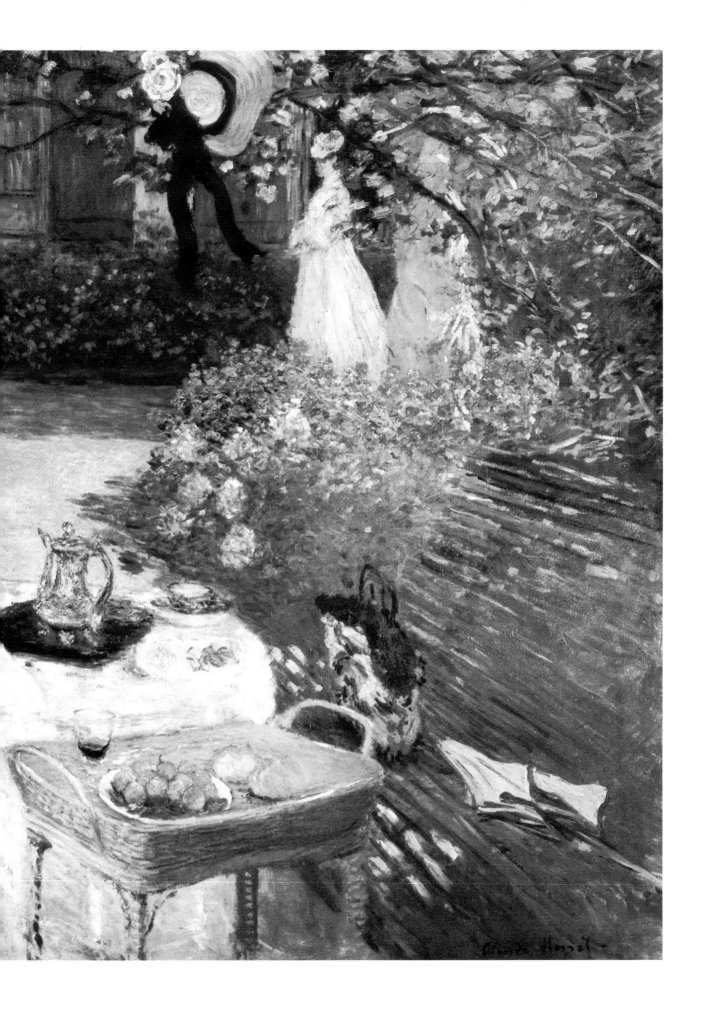

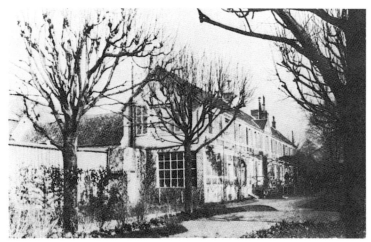

*The house and first studio in winter. Collection Piguet, Paris*

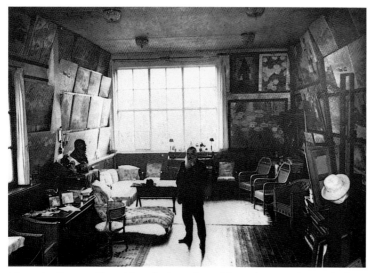

*Monet's first studio with paintings from his entire creative period, ca 1915. Collection Piguet, Paris*

*Monet's house today*

The bedroom is the resting place of a strong-willed man who, when he is plagued by self-doubt, hides from the searching eyes of even his own family. He stays in bed, as he does when fast-moving clouds chase across the Normandy skies – his skies – and disrupt his pre-arranged plans. And the sky at Giverny is not always blue by any means: such is the fate of the outdoor painter. His large curtain closes while he rages and grumbles. For Monet, the world ceases to exist.

## The garden

And yet it returns. The first bright light of dawn floods the garden. It finds the painter cheerful and calm among roses that are still drowsy with sleep, among dew-covered irises, growing in a long, orderly line – his favourites. Their cool fire glows in muted tones. At this delectably early hour, when the birds are freeing themselves from their nocturnal stiffness with song, Monet can be found among his borders, with the flowers of his choice, in the tranquillity that envelops his garden. You have to imagine him for yourself: brooding, completely given over to his observations, not so much of how the flowers are growing but of the modelling power of light. Here, his ideas for paintings are taking shape, often at breathtaking speed, while the house still lies in a deep slumber. We will speak later of how he sets off for work, into the morning haze and early light, into a nature that rises from the mists of the night and into the magical world of his garden, which he has captured both flowering and fading on his canvases.

## Monet's appearance

Monet's appearance as it is reported is also of interest here. He seems to have enjoyed 'posing', probably in the knowledge that he made a good picture. Hélène Adhémar[5], to whom we owe the exhibition of Monet's work in the Grand Palais in Paris in the spring of 1980, quite rightly decided that his image should not be defined by the good-natured photographs of elderly people: the painter with his white prophet's beard, his head covered with a soft felt hat or, in summer, shaded by a broad-rimmed Panama hat. Giverny also knew the other Monet, black-bearded and with glimmering eyes as black as tar, as

*Illus. p 23*

[5] In the preface of: *Hommage à Claude Monet*, exhibition catalogue, Feb/May 1980, Paris, Grand Palais

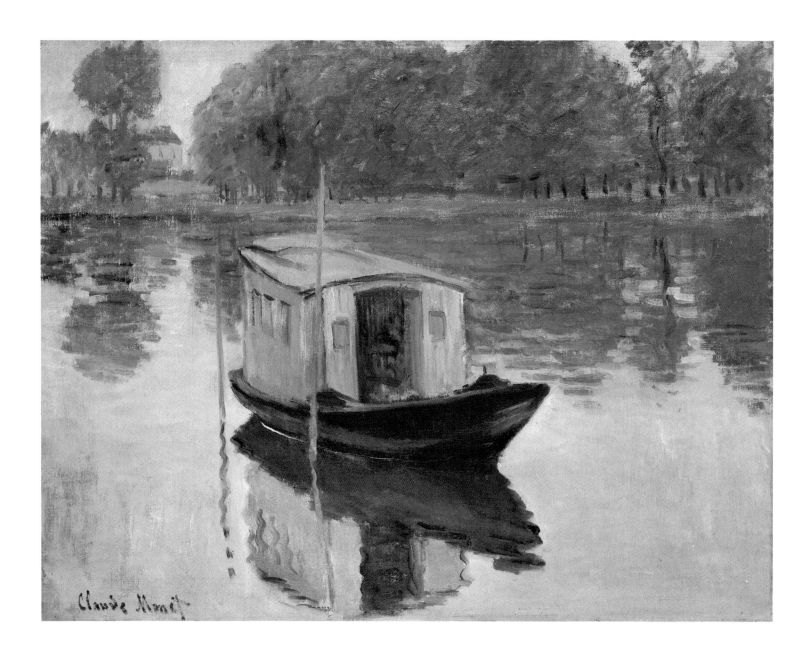

*The Studio Boat. Ca 1874*

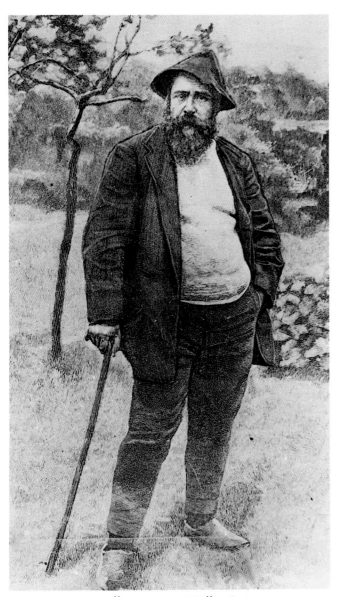

*Monet, ca 1895. Collection Roger-Viollet, Paris*

*Monet in typical pose, ca 1920. Collection Sirot, Paris (photo: Bulloz)*

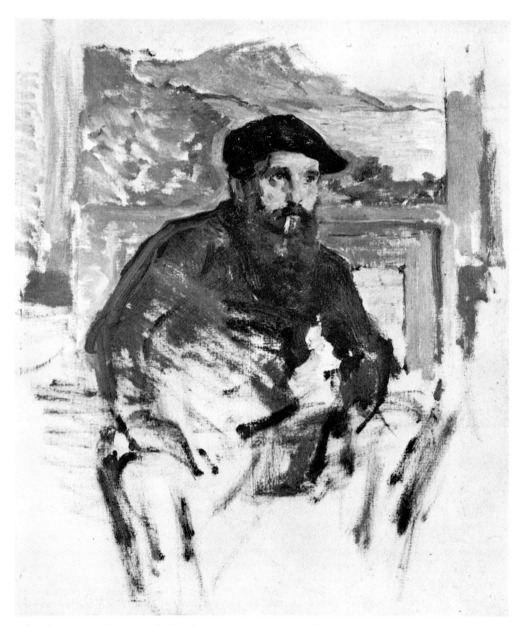

*John S. Sargent, 'Portrait of Claude Monet'. Ca 1885. Collection Howard Johnston*

[6] John S Sargent (1856 Florence–1925 London), American painter

he was painted by John S Sargent[6], with his beret and the inevitable cigarette in his mouth, seated yet always ready to jump up or pounce. There is a reason why his figure is painted with only a few brush strokes – it is a moment of friendly enthusiasm captured in a picture. It was Sargent, too, who very early on obtained the most beautiful of Monet's water lily pictures for keen American collectors.

Thus the picture of Monet, ready to pounce, is not a critical sketch, nor is it a kindly portrait like the one Renoir painted in 1875[7], full of gentle softness, during a break in painting, which shows nothing of Monet's worries about providing for his family in those years. Even so, such pictures of the young, strong-willed son of the coast, the defender of Impressionist painting, do not show the 'great gardener', the creator of Giverny. We recognise this person in the imposing figure who becomes memorable through his never-changing presence, customs and habits: protected from sun and rain to the same degree, in inconspicuous clothes which get lighter and ever more beautiful over the years, amid a sea of flowers, in front of his canvases, silently contemplative and immersed in his work.

Everything about him is plain and gives him a casual manner that is suited to both work and painting. Today's elderly grandfathers can easily recall their own forefathers who lived in the country after abandoning an urban past: their clothes and appearance, habits, meals, the rhythm of work and rest, their lives following the course of the sun without distractions or interruptions. And so Monet lives, modelling the maxim of 'early to bed, early to rise' for his family, a saying that echoed strangely of another, more sinister one of the time: 'early to rise and late to bed … and you will regain lost chattel'. Such an admonition, meant for that epoch and for Monet's generation, reflects a time of transition and changing routines.

*[7] Auguste Renoir, 'Portrait Claude Monet', 1875, oil on canvas, 84 x 60 cm (33 x 23 ⅝ in), Paris, Musée d'Orsay*

## Making plans

For every hour of his years at Giverny, Monet knows what he owes to his own capacity for work and what he owes to himself, even if he seems to have forgotten the outside world while painting. As a man who fled to London during the war of 1870, and as a neighbour of his great compatriot Flaubert, he shares Flaubert's scepticism and view of the world, although he was less demoralised by the fall of the Second Empire. Along with Flaubert, who now regards all art as a 'useless activity', he shares an unhappiness with what he has created. Despite all his genius.

So, to the attractive sedateness of old age, to a temperament ready to bear the wind and weather, to the man who is wrapped up and ultimately concealed, we now have to add the powerful, the wonderfully wild and defiant, the matter-of-course, always ready to act, the well-thought-out and the economical in his personality in order to understand how Monet – just like a chess-player

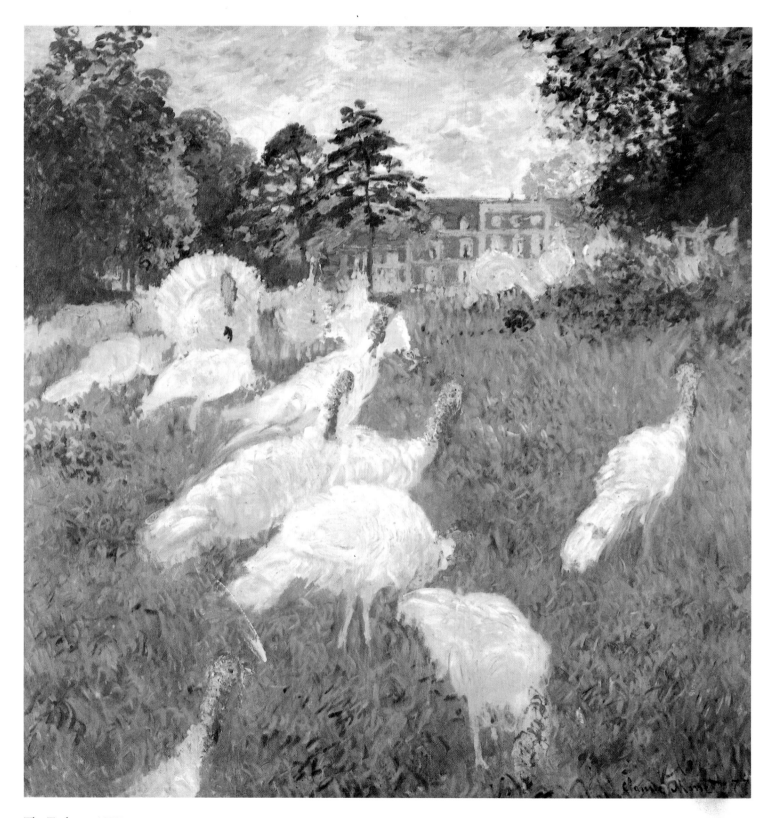

*The Turkeys.* 1877

– makes one surprising and overwhelming move after another. How he has a second studio erected in the garden; how he liberates the *Clos Normand* from its high walls by having them knocked down to half their height and then allowing them to be overgrown by 'living' hedges – flowers instead of bricks; how through hard negotiations he manages to acquire a piece of bog at the foot of his garden, which extends lazily in the sunshine, then has a pond dug out which is fed with fresh water by the little Ru stream; how he admits trees and shrubs in an 'orderly wilderness', creating great beauty, shade and atmosphere; how with the aid of his gardener Félix Breuil – a master in his field recommended by his friend, the writer Mirbeau – and his associates, he creates the islands of water lilies and poetic plantings on the banks to fulfil his wishes.

*Illus. p 39*

There is always another plan, be it a garden house or a tarred road next to the railway tracks, which in a somewhat prosaic manner separates the two gardens. But in this way the dust is banished, and who today is familiar with the bright sandy cloud thrown up by rural vehicles on a summer's day, which would hang in the sky for an eternity, depriving the roses of their colour.

The gardens are meant to flourish through three seasons – spring, summer and autumn – with their flowers in all shades, from a delicate white to a persuasive red-violet, and so greenhouses are built, which also allow the more tender plants to overwinter. The young garden helpers need accommodation, so this is built. And when the work of the painter extends into the cosmic sphere, with its silent water lily islands and *saules pleureurs* (weeping willows), when this vision becomes overpowering as he enters the realms of very old age, when he returns to the studio for the first time after painting *en plein air* for decades in order to create large-format studies and pictures from his 'inner image', he has a third, giant studio built in the year 1916, despite wartime shortages of materials, in the north-eastern corner of his estate. Nothing is amiss here, and Monet is able to paint in the heat of summer as well as in the cold of deepest winter – very unlike the conditions in his poverty-stricken youth when he had had to dig a ditch to place the canvas in while painting the upper part of the picture.

*Illus. p 120*

Considering the unshakeable willpower and taciturn distance of the landlord, it is hardly surprising that the 'strangers' eventually gain respect and a limited sort of popularity in the village. It has often been told how the habitual beggars were soon demanding their share at the door, how the craftsmen benefited from the numerous changes, how the farmers took advantage of him with a 'road toll' and other little harassments of which we shall speak later. The reader is reminded of it here because it is the only way to understand this

paradise he had wrung from the village. Monet's standing is made evident by how he himself pays to have the *marais* drained, the bog once covered in thousands of shining yellow lilies, in order to secure his water garden; by how – now with a more powerful voice among the farmers – he prevents the erection of a cornflour factory with smoking chimney stacks. The villagers, who had resigned themselves to all the changes with a grumble and who could only be placated with a lot of money, eventually come to see the daily departure of the painter for work in a new light: the eccentric becomes their provider.

## *The village changes*

Giverny steps out from anonymity, not entirely to the joy of Monet. Strangers, admiring painters and various artistic youths threaten to disrupt his peace. The children are straining out and bring turbulence. Monet has to hide, lock himself away, strictly insist on peace in the house. He alone decides who is to be a guest at his table and he soon learns how to withdraw from infatuated admirers. The hurly-burly and the flood of visitors who would have bombarded him with wishes large and small – it suffices to read the list of important contemporaries who visited him more than once – would have made him lose sight of his most important intention, his real aim in life: to paint, to relax from this activity with numerous canvases and in this rhythm to preserve himself and his work.

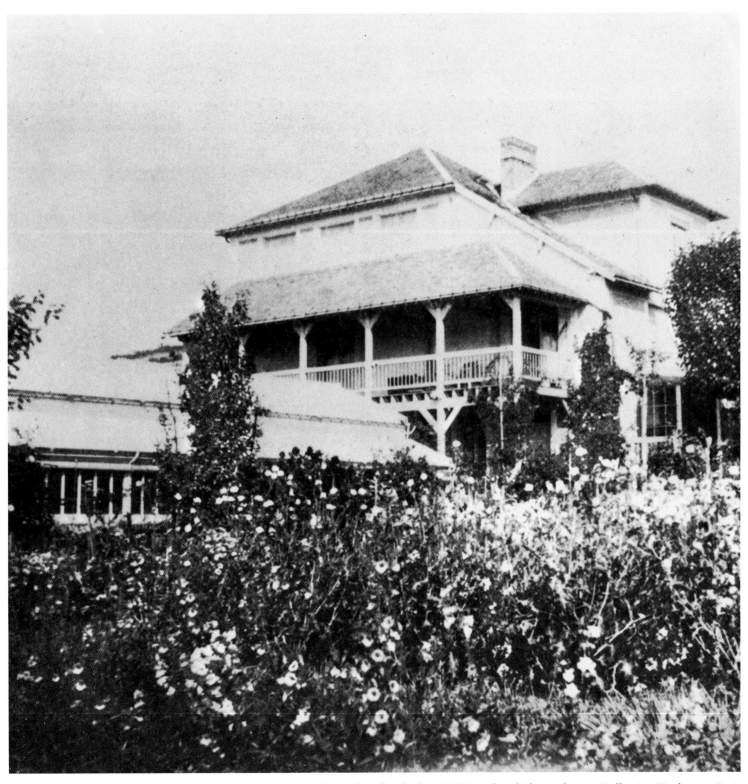

*Second studio, built in 1897, and orchid greenhouse. Collection Toulgouat, Paris*

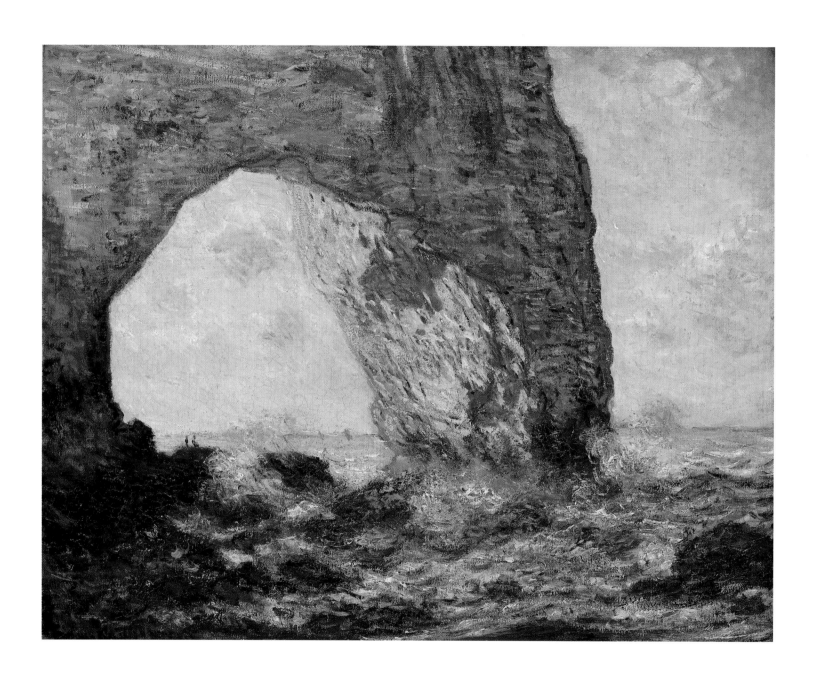

*The Rocky Cliffs near Etretat. 1883*

# Intimacies

*The nearby rocks and hills – The Seine, her bays and islands – The marais*

Claude Monet has also been called – with a certain naïvety – the greatest painter of Normandy. Such an appropriation of this historic region between Paris and the sea, the Baie de la Seine and the Côte d'Albâtre, is thus considered permissible and plausible. Monet's childhood home in Sainte-Adresse, on the mouth of the broadening river, just before the great harbour headland at Le Havre, is more important than Paris, his place of birth; his character is more obviously shaped by Normandy than by urban contexts.

Of course, everyone had to go to Paris eventually, regardless of which direction they were coming from. It was Eugène Boudin, himself busily painting on the beach at Trouville, who sent Monet there. But the element that constantly drew Monet with its magical powers was the water, the stream, the river, the ocean: again and again and in many a place from Argenteuil and Asnières on the Seine to the Normandy coast, Dieppe and Etretat, to the Atlantic beyond the Brittany coast and, offshore, the rocky cliffs of Belle-Ile.

And yet, whether during his days at Giverny, or on his quest for ever new, exciting subjects, from Sweden to the Côte d'Azur, it is the lower course of the Seine, with its many

'La Manneporte', *Etretat*

meanders, that the well-travelled painter is most intimate with, just like many of his painter friends. It is no accident then that his journey ends at Giverny. Yet, unlike Coto or Daubigny, he does not create an image of the surrounding countryside, the grand scene, the wide plains, the picturesque formations of the whitish rocks peeling out of dense greenery.

He no longer 'narrates', instead he has fallen for a life with the river, the phlegmatic Seine, which does not move from the spot, its meanders under the rock faces; which forms bays and dead ends, islands and islets, from one bow to the next; which admits plenty of overgrowth and undergrowth so that in winter it is pushed and broken up, piled up and layered in icy drifts. The brushwood of the water birds, the reeds and the shallow spots, the bathing places and idyllic fishing grounds, they make the boatman berth, just as they do the painter. Water, endlessly gurgling and swirling, bubbling and foaming, and finally still and smooth like a mirror, without any ripples, without the slightest curling, yet enriched by the reflections of an imaginative sky: this is the painter's real subject.

And then the *marais* (the swamp or boggy meadowland), and its inaccessibility, the meadows beside the water, magnificent with their wild flowers spreading luxuriantly like weeds: they too are reflected. It could be thought of as the highest art form, paying homage to a 'home' with pictures, even if the landscape itself is just a pretext here.

It is of little consequence then whether we can trace the exact location that a subject was painted from, either at Giverny or in one of the bays of the Seine, or whether it is possible to repeat the experience of the morning or the midday hour. For what Monet transforms into art, what leaps from a picture into the mental experience, has long extracted itself from its place of origin. How else can we explain the lasting effect of Monet's most beautiful pictures on the far corners of the world? And where he – who destroyed many a picture that he considered a failure – has not fully fulfilled himself, the sensitive observer will feel it too, without running into the spring meadow where Monet struggled with his 'vision'.

## The Normandy coast

A special magic weaves itself around the rocky coastline of eastern Normandy, from Dieppe, via the wide outpouring of the Seine into the sea, to the Côte Fleurie with its spa towns of Trouville, Deauville and Honfleur, which today,

just as a hundred years ago, still count innumerable holiday visitors in summer. Since Isabey, Jongkind and Boudin, even Delacroix, painters have enjoyed the local sights in a manner appropriate to their artistic genius: the high-lying pastures, unexpectedly replaced by steep, stony walls that suddenly plunge into the sea, picturesque as only wind, weather and the persistent gnawing of the waves at high tide can make them, deforming them, hollowing them and washing them out. Over thousands of years, the sea has carved bridges and gateways into this proud fortress of nature, near Fécamp and – probably the most famous – near Etretat, with its rocky noses on stilts. Here, the *Porte d'Aval* with its cheeky 'needle' – the rock formation called *Aiguille* – is like an outpost sent into the sea but still remaining a part of the mainland. This formation, together with the bays and the steep wall up to the next grotesque formation that juts out into the sea, the *Manneporte* or 'willow-basket gate', is a world-famous motif.

*Illus. p 76*

To the painter, these 'games of nature', burlesque and at the same time grandiose, must have seemed like resting, drinking elephants and giant horses, at times sporting a green cap hanging down over their foreheads, at times with an autumnal pallor, as if blond-haired, when the grass at the top has withered. Below, sand and light flint pebbles are exposed by the receding tide, along with brownish-black mussel banks. High tide brings the powerful thunderclap of the waves crashing against the rocky shore. Such is the natural drama of the tides.

Monet is at home here, as much with the surging high tide as with the glass-like sea in the lazy stillness of summer. A good ten years earlier, in 1870, he had painted individual women, flat-featured as was the fashion, within the strong shadowy darkness of their parasols and of a peculiarly penetrating ugliness, as if the boredom of respectability had entered their faces. These were 'apprentice pieces'. Monet eschewed the light scent and palette of paintings by Boudin, who in the lightest and most delicate manner had captured Parisians lining up on the summery beach as if in a continuous open-air matinée show. Monet's subject is the powerful language of nature: the small fishermen's fleet pulled up onto the beach at the foot of the whitish chalk cliffs, out of reach of the rising spring tide and protected in winter by little houses, the *caloges*. One such dark box, reminiscent of an ark, can still be seen today – a reminder of Monet's pictures[8].

Cold and storm, the sea whipped up, a few forlorn figures – mainly to hint at scale – fishing boats banded together at the foot of the cliff, which rises to 60 metres and takes on a different coloration every hour: these were Monet's subjects before he devotes himself entirely to the study of light, before the

8 Cf Monet's painting 'Fishing boats on the beach at Etretat', 1884, oil on canvas, 74 x 101 cm (29 1/8 x 39 3/4 in), Cologne, Wallraf-Richartz-Museum

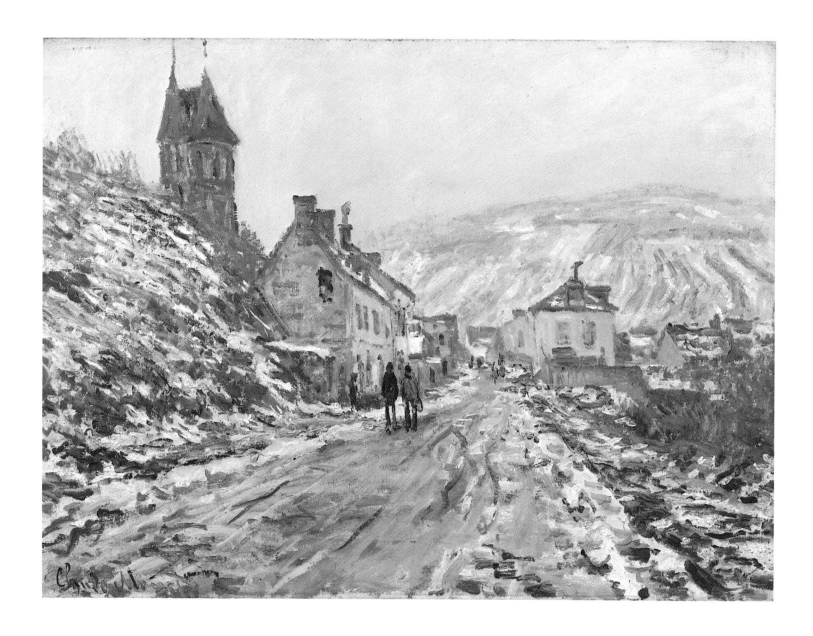

*Vétheuil in Winter. 1879*

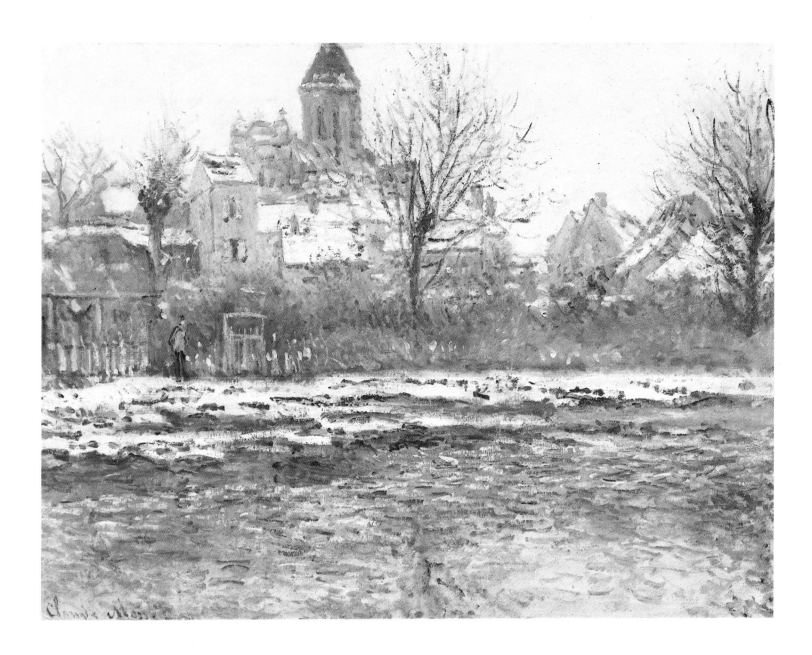

*Church at Vétheuil. Snow. 1878/79*

people are lost from his canvases and he is entirely caught up in the play of reflections on the water, lit up by the sun, in the airily open arch of the Manneporte cliff. Powerful coloration and a strict demarcation of the scene in the foreground were often necessary here; at times a coloration not unlike that used by van Gogh. Such paintings from his restless years, when he breaks out of the confines of unhappy living quarters, lead right up to his first days at Giverny: from the familiar, matter-of-fact view, he moves on to the dramatically exaggerated, painterly subject and finally to the sparklingly translucent stone arch, hollowed out by the sea, on which cool and warm colours are interwoven and interplay. The brush seeks to follow the clearly visible, striped layers of sedimentary rock – horizontal, as if in a giant, crumbling, layered cake.

*Colour plate p 40*

The ever restless fringe of the sea, the transparent tide thrown back in gruff agitation under the rocky cone on which it breaks as it rolls over, becomes the subject of a painting which, in order 'to be read', requires a calmly drawn distant horizon where sky and high seas cheerfully encounter each other.

For Monet, the Normandy coast is not a travel adventure that stirs amazement or admiration, like Norway or Venice. It is his model, inherited from childhood days. The great water with its persuasive power over his subjects, with its summary gestures under sun and rain, has only tolerated the 'picture-maker', his easel weighed down with stones, who always has to be prepared to break off his work in the rapidly changing weather. When later he recognised the unique powers of the transformation of light, Monet searched for calmer surroundings, regions that were protected from undesirable, ever curious people.

## Vétheuil – an escape from narrowness

[9] Camille Doncieux, Monet's wife, died here on 5 September, 1879

Only an S-bend upriver from Giverny, with 'its feet in the Seine', lies the village of Vétheuil, a fateful town for Monet[9]. Today it is almost entirely deprived of its former village charms, even though the nearby rocks are still piled up just as attractively. The view spans the river lowlands towards La Roche-Guyon, where Renoir settled and installed himself to paint.

And here, too, the Seine, with its many channels, slows down its course. The artistic sensations it held when Monet painted here in summer and in winter, immune to both the heat and the cold, are passed on in delightful pictures, which once and for all take over from his studio art of previous days

*Monet's house in Vétheuil today*

and lead onto the incomparable paintings *en plein air*, and eventually the style of Giverny, the dramatic impressions of the water lilies.

How vitally important it was for him to escape from the narrowness of the small house at the foot of the rocks (which today bears a plaque commemorating its most famous former inhabitant). Camille, Monet's wife was sick after the birth of Michel, courageous Alice Hoschéde and her six children were living under the same roof, and the painter was always on the lookout for pecunious buyers for his pictures. Only work in the outdoors remained: in the small garden, which sloped down towards the river where high water caused many problems; on the banks of the Seine; in the meadows and also on the water, in the roofed boat.

*Colour plate p 53*

*Colour plate p 32*

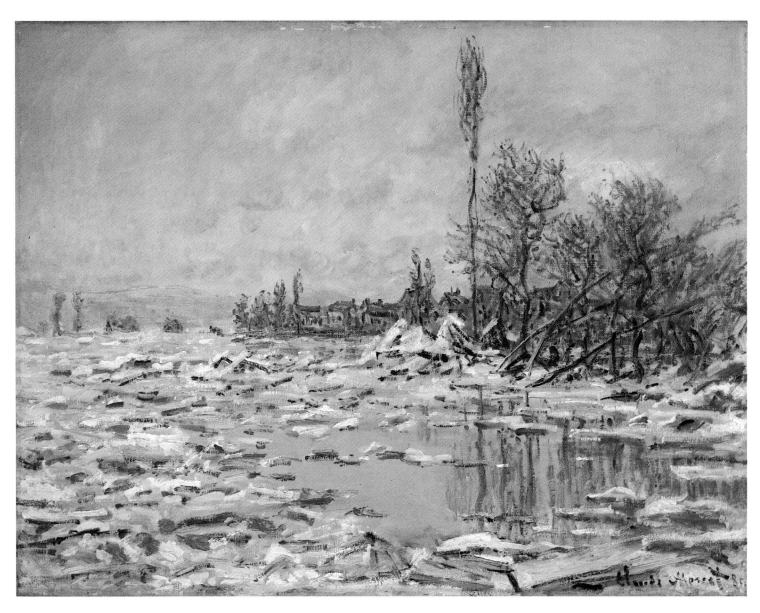

*Drift Ice at Vétheuil. 1879/80*

'I have painted the Seine all my life,
at all times of the day and the year.
I have never grown tired of her: for me
she is always new.'

When we look at the pictures that Monet created here, his misfortunes no longer seem present. These paintings reveal a skill that makes us forget some of his earlier forcefulness of style and certain forced painterly effects. Even the much-praised period of Argenteuil – under the watchful eyes of Manet – now seems to be no more than art which, albeit in a grandiose manner, showed up the common ground shared by the Impressionism of Pissarro and Sisley, of Renoir and Monet.

Monet, however, does not partake in further experiences. Unlike Pissarro, he is not impressed by the Pointillists Seurat and Signac and strays further from the beautiful sun-flooded picture essay of his Parisian days. His unruliness gains the upper hand in him. The boulevards and the summer idyll of the Grenouillère[10] are no longer seductive themes for him, nor is the view out of a Paris window onto the 'human swabs' and 'carriage blots'.

With his pictures of Vétheuil he makes his home amid the boggy waters and the icy floes. The 'thrust of the ice', the drift ice uprooting tree and shrub on the wilful, uncontrolled Seine, becomes the dominant theme in the pictures he now creates.

There is no comfort or cosy warmth in such work produced under open skies, no 'happily inviting meal with friends in a shady summerhouse' when he returns from his Seine meadows, completely exhausted and drained by the concentration needed to capture a back-lit mood, the heat shimmering above the flowering glory and between the distant trees. And yet in these much more delicate pictures, whose infallible effect does not hark from the bright red poppies, and in the winter pictures, which only permit soft shades of brown to be perceived between the greenish ice of the floes that are loudly piling up on the jamming river, an ever more self-satisfied process of picture creation creeps into motion. The subject loses much in importance: Art, on the other hand, gains in urgency.

The paintings of the drift ice make this obvious. They quickly supersede one another as if Monet was worried that he would miss a single mood of winter gloom or a single phase of the drifting ice floes. Although these paintings are often necessarily and deliberately sketchy, the version in Lisbon achieves perfection, probably thanks to having been created on a lucky day. It is a masterpiece: water and ice floes, right up to the not-too-distant pile-up and the collapse of tree and shrub vegetation on the right bank – a frozen village beyond – submit to the self-willed brush strokes which merely scrawl, indicating the silent drifting, stopping and jamming, pushing and crunching, the rearing-up and the diving-under, area by area and piece by piece. This is the reign of 'winter' with all its force.

[10] 'La Guinguette de la Grenouillère', a garden restaurant on an island in the Seine near Croissy, north of Paris, frequented by Monet and Renoir

*Colour plates pp 50/51*
*Colour plates pp 60, 61*

*Colour plate p 48*

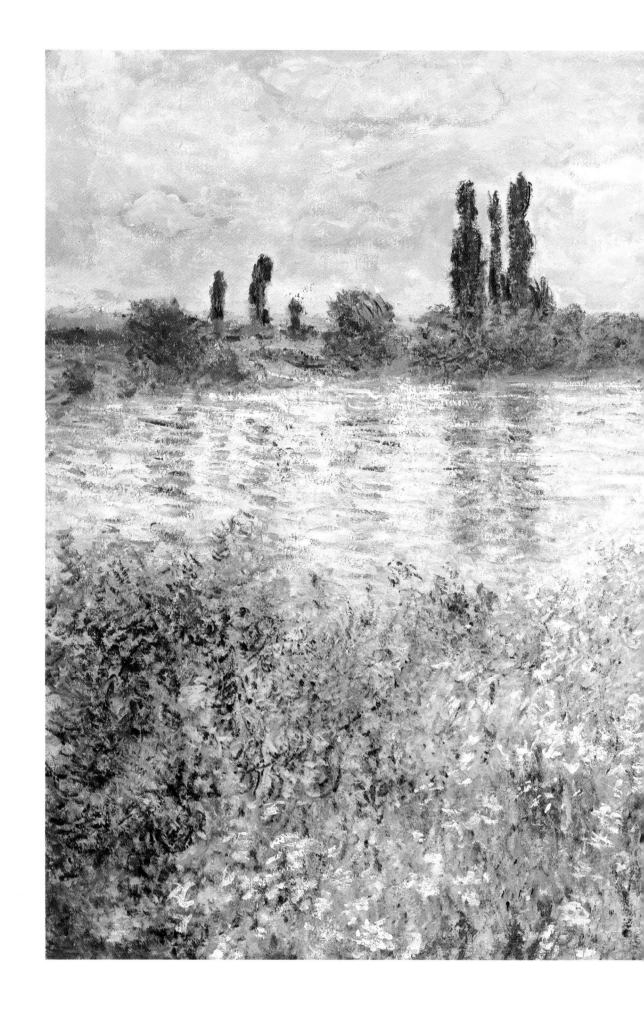

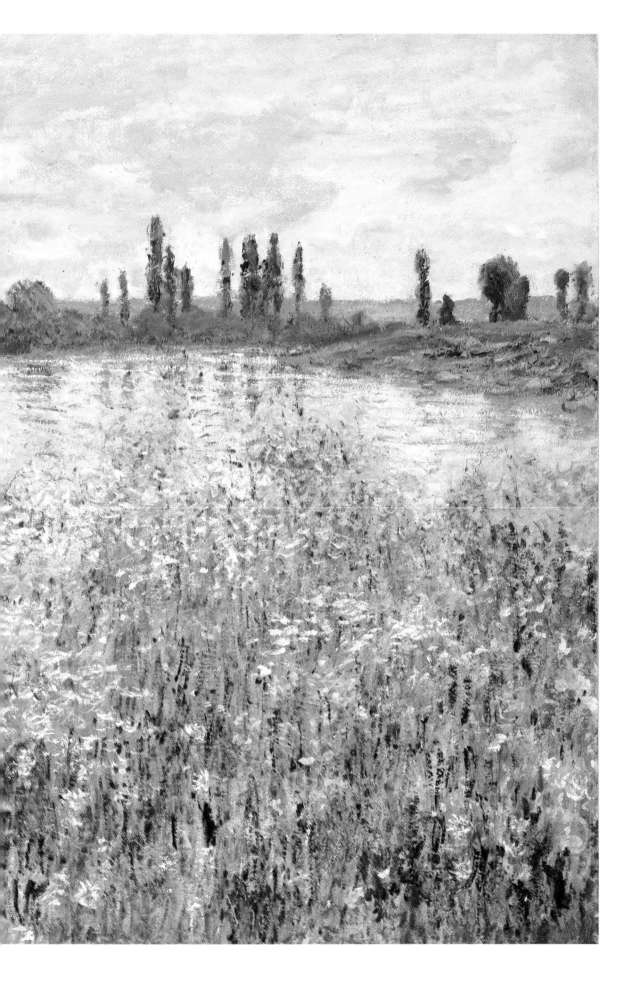

*Banks of the Seine at Vétheuil.*
*1880*

Monet's acute observation misses nothing, neither the pinkish hues in the sky nor the single shadow of a tree in the seemingly motionless water. Even time seems to stand still here, although the fleetingness of the moment has determined Monet's work. If we think of Cézannes's 'firmly cemented' picture, in which it is impossible to read 'moods', then Monet remains faithful to himself even here by indicating the wintery time of year with the help of passing clouds.

The wet and cold days of watery snow cannot stifle the smell of earth from the gardens, nor the odours of the village kitchens and stables, nor – if we let our imagination run freely – the gently hypnotising cloud of incense that wafts out of the open double doors of the highly placed church of Vétheuil with its devout churchgoers, and escapes into the grey winter sky. These dull, rather than severe, winter days on the Seine inspired Monet in a lasting manner. With these winter scenes, the painter bids farewell to cool whites and cold colours altogether.

*Colour plates pp 44, 45*

In his floating studio or on one of the many little islands he finds 'impressions' of a quietly enchanting density. His painting 'Church at Vétheuil. Snow' of 1878/79 shows one of the purest and most beautiful uses of a muted colour palette. Above delicate, greyish green house façades with a hint of warmth, behind the gentle violet of a hedge and brownish green pastures, he places bluish white dots up to the church whose tower touches the edge of the picture with its roof. Colour is preserved as if behind a veil of snowy air, yet throughout it has a graduated richness, making us admire Monet's inventiveness. His position is well chosen; it permits him to paint his subject – the silhouette of the village rising beyond the outline of the hedge – right into the winter sky.

*Colour plate p 45*

Below the demarcation of the hedge there is the opportunity to translate a bank of dirt and snow into art and to do justice to the waters of the icy of the river with a new painting technique, a series of short parallel strokes, albeit without any strict formality, angled towards the viewer. Gruff and grey-blue, it tremblingly reflects only the three trees that rise up from the hedge. The brush penetrates the unmade bank, 'leaping' in with dark areas in order to set a powerful mark where the bank is firm, and darts across the water in short whitish strokes to keep the shadow of the village light: in winter, light has no strength.

Even if one prefers the earlier pictures from Argenteuil to this more intimate work, one would have to admit that Monet's discourse with his subject marks a distillation from the sudden and persuasive to the quiet, from the concrete to the atmospheric. He never painted the garden at Giverny covered in snow,

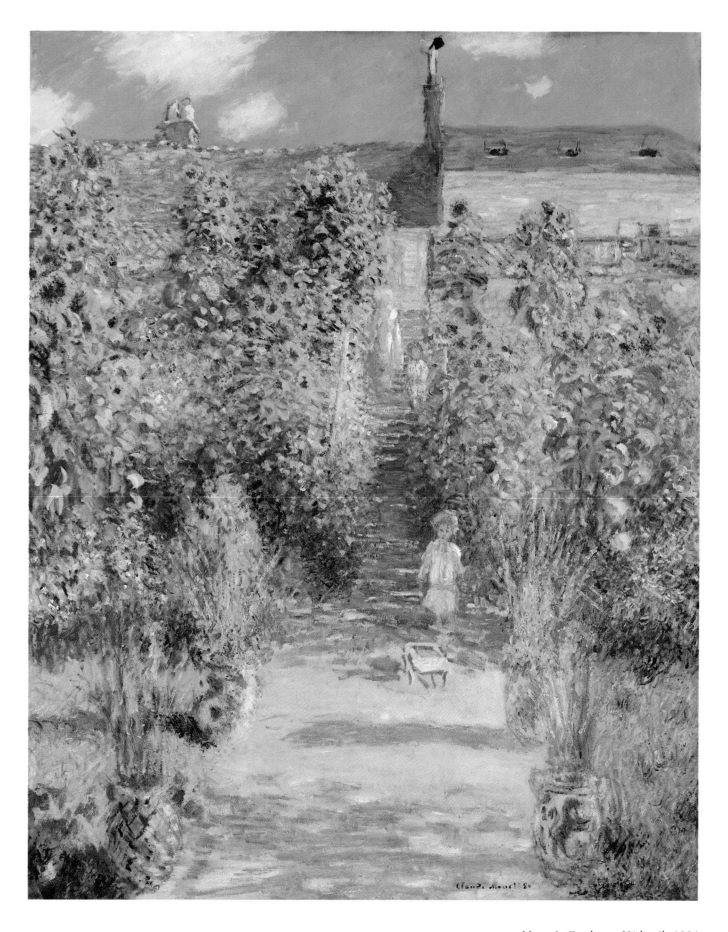

*Monet's Garden at Vétheuil. 1881*

for black and grey and all the shades in between completely disappear from his palette there.

A single dominant theme now emerges: no hour is like the next, as he has already experienced in his studies of the drift ice on the Seine under a leaden sky. The cold mist above the water, met by the sun's rays, billows up into a cloud and sprays apart: the scene is transformed without even a single floating branch having changed its position.

Light transforms, emphasises, shapes – and also deceives.

## Vernon

*Colour plate p 55*

Having only just found 'his' Giverny, Monet's view of Vernon, as seen from the Seine and painted in a cheerful light on a beautiful summer's day, again contains more of his delight in an important subject which, like Vétheuil, 'rises' in front of him.

The view moves across the wonderfully reflective water, whose trembling, interrupted reflexes are marked with little brush strokes that float past, to the embankment path and the town walls at half height, above which rises a historical celebrity, the Church of Notre Dame. Everything is unmistakably shown here: the straight outline of the eastern choir – originally the remains of a Romanesque tower – the sunny, narrow, high nave and the steep roof up to one of the delicate western towers. There is no break in his painterly description: effortlessly he manages to depict a plethora of architectural forms used in a building that it took four centuries to finish. Behind it we glimpse the tower of the town hall, further buildings huddled around a once important village square, border fortifications between Normandy – then part of England – and France, with a fort built from beautifully dressed square stone blocks as a 'bridgehead'.

To frame the medieval buildings, Monet uses, on the right, the dark green of a small park as far as the charming group of houses built in more recent times and, on the left, small, round trees down to the river bank. Undiminished harmony transcends the picture from one corner to the other, and from the cloudy white sky to the surface of the water, in which the firm shapes dissolve. The little town has long since changed its appearance: its embankments are now built up as defences and the art of the stone mason hides behind ivy.

In the summer of 1883, Monet still had the 'worthwhile' subject before his eyes: the towering church and its 'response' – a brightly sun-lit secular building,

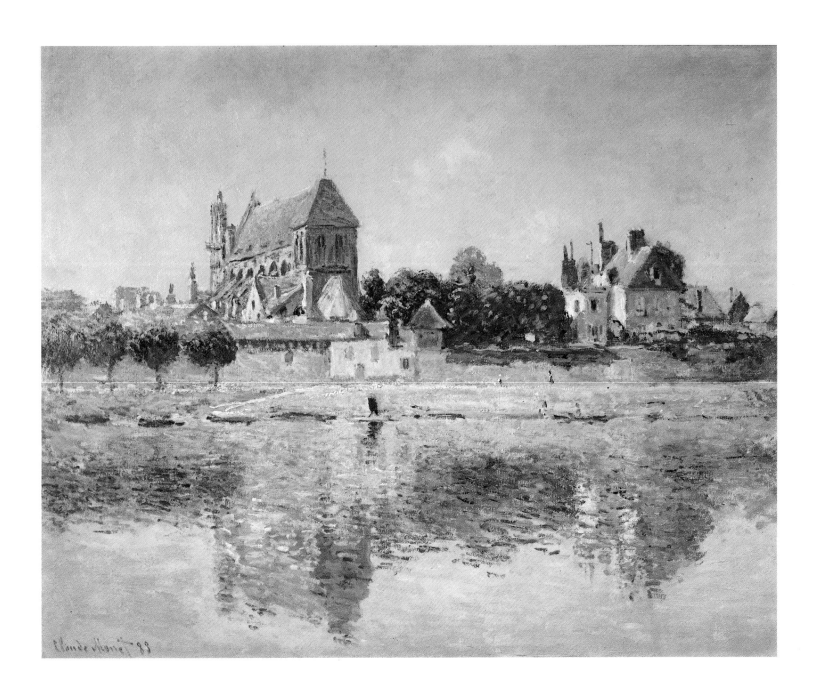

*Church at Vernon. 1883*

kept at a distance by trees. This is 'unposed' scenery, a townscape before the intrusion of the industrial age with its chimneys and railway bridges. The rural idyll, its rich fund of history preserved in stone, still reigns supreme. By following the delights that his eyes have lit upon from beneath the shaded roof of his studio-boat, the painter also hands down to us a piece of the past.

There are, then, 'intermediate stages' in this initial phase of the Giverny years, stages ranging from the persuasiveness of the subject to its retreat behind the painter's ideas.

# Picture series of the changing light

It has often been said that during Monet's time at Giverny – to which the jewel-like paintings of the western façade of Rouen cathedral, painted from a window, also belong – the artist's approach to the landscape surrounding his garden was not to remain faithful to its topography, but to study the phenomenon of light on objects. A prerequisite of this approach was that buildings with a great wealth of detail, haystacks of a beautifully round shape and poplars of a slim habit had to lose their vegetative properties and peculiarities and merge into an inalienable density. Monet now pursues this – working continuously until he is physically exhausted – to a ripe old age, eventually seeing almost entirely by feeling and culminating with his 'Nymphaeum', one of the greatest artistic achievements of that period and perhaps of all time.

Although in the beginning Monet believes that he can show sufficiently clearly how decisively a subject changes in different lighting conditions by painting two pictures of the same haystack, from the same vantage point but at different times of day, he soon recognises that such crude, shorthand devices fail to achieve what he intended. He realises that the logical consequence of Impressionist theories – and these had been hotly debated in Paris – would be to capture every single object in its infinite number of manifestations, since the quality of the light determines every perception during each half hour of daylight. It is only by recognising this that he sets his imagination of colours free and comes to rely entirely on the sensitivity of his eyes – something that was to become an historical event when initially it seemed to mean no more than the 'loss of subject matter'.

When we look for an intellectual affinity to this way of thinking – the exhaustion of a theme through its endless variations, to which we owe pictures that were never again painted in such a large number, overwhelming the theories – then we may think of the *grisailles* by Eugène Carrière[11] called 'Maternités', that look as though they have been 'breathed' onto the canvas. They were created at the same time, during the same decade.

Before following Monet as he translates his insights into the alternative reality of the picture in his paintings of haystacks, rows of poplars and the

[11] The French painter Eugène Carrière (1849 Gournay – 1906 Paris) painted a series of pictures devoid of colour from 1879, all with the same theme *Maternité* (motherhood)

morning atmosphere of the Seine, we shall briefly return to the scene of rural Giverny, to the time when the Monets and Hoschedés have just moved into *Le Pressoir*.

The farmers, or rather *cultivants*, of Giverny are not content just to be amazed by the activities of the painter and his family. When a track becomes visibile across the meadows where Monet walks early every morning to the Epte or the more distant Seine, accompanied by Blanche, always faithfully dragging his painting materials behind him, the cunning farmers devise a 'meadow toll'. Monet pays it. And when – as always – he makes his way over to 'his' haystacks, he finds the farmers are just about to take them down, and rather gloatingly so. Monet buys himself a 'stay of execution'. When – as so many times before – he makes his way down to 'his' poplars by the Epte, he notices that their trunks have been marked for felling with an axe. Again he dives into his pockets in order to save his subject.

Then, one morning, when he gets to the Seine, where his studio-boat and the *Norvégienne* – a lightweight boat that does not capsize – have been tied up to a willow on the bank, he finds the rope cut. The boats have drifted off: they are found again (those were leisurely days) at the lock of Port Mort, a good way downriver. Monet keeps his anger to himself and buys the small Seine island of Ile aux Orties to ensure his peace. And although he is victorious in all these little 'battles' against the farmers' reluctance, against the rejection that comes from a lack of understanding, it nevertheless demands much self-control for him to stay in charge of the situation. And it is a long time yet before he will have a carriage to take him to his subject, and will have finally gained the grudging respect of his fellow citizens.

The work he now creates betrays nothing of these disruptions and harassments. In time, painting after painting, in quick succession, begin to find admirers and buyers, laying the foundations of a fame that will never again pale. Every single subject is presented as a 'series'; Monet's position changes less often than the all-determining light.

*Illus. pp 74, 75* When he paints his *motifs matinaux*, the morning studies on a calm branch of the Seine, the sensation of the ever-changing light becomes so urgent for him that he always chooses exactly the same spot to paint, in front of the trees overhanging the water and reflected within it. What he achieves with this subject is one of the most beautiful paintings of his entire *oeuvre*. We can still understand today how profound the emotional effect – a suppressed jubilation at a supreme achievement – of such pictures must have been. Contemporary

reaction, when the first picture series were shown at exhibitions, was divided between gushing enthusiasm and cool non-comprehension. The Paris audience of the Salons stuck with its preferences for the 'narrative'; critics on the other hand – most of all Gustave Geffroy[12] – inclined entirely towards the painter, who forbade the use of the title *maître*, but who was unable to prevent the effusive excesses of his interpreters.

[12]Gustave Geffroy (1855–1926), art critic and writer, friend and biographer of Monet: *Claude Monet. Sa vie, son temps, son oeuvre*, Paris 1922

The objectivity with which Monet silently works, day after day when the weather permits, is one of his Norman character traits. This is also how he manages to become the master of his paintings, these many children of a great colourist who uses ever new colours to capture his subjects. Since form is no problem for him, he can raise the How above the What. For someone who continually doubts and judges himself this does not mean, however, that he is certain to triumph in the end. Making decisions about his subjects in solitude, he cannot afford to worry about their effects. His younger years, when his friends encouraged him and cheered him up, are long gone, as are those of his comrades.

If one says of Monet that he was one of the first to paint a landscape 'unposed', to have neither elevated it to a heroic scene by leaving out or moving individual elements, nor to have eased it into an idyll, then this is true only up to the threshold which he crosses with his series of pictures on the same subject. When considering his search for subjects we are again and again confronted by Monet's astonishing determination to abandon picture narration altogether. Looking at his 'Church at Vétheuil', the picture of a mild winter's day – the timing being indicated by the man in front of the hedge wearing his blue farmer's overalls – we see the very last picture where it is still possible to sense a gentle seduction that makes us want to explore the fate of the village and its villagers with our eyes.

*Colour plate p 45*

*Colour plate p 45*

## The poppy field

Two years after the summer picture of Vernon, Monet sets up his easel in front of a poppy field in a hollow in the open fields of Giverny, which climb towards the north. This 'natural bowl', fringed by bushes and dotted here and there with shrubs, is filled with cool and warm colours: young corn and blooming poppies, pale blossom at the side. Monet creates depth with his central red-dotted area and the lighter regions advancing from the left and right, which are delineated by the colour stripes that sway through the hollow only to be

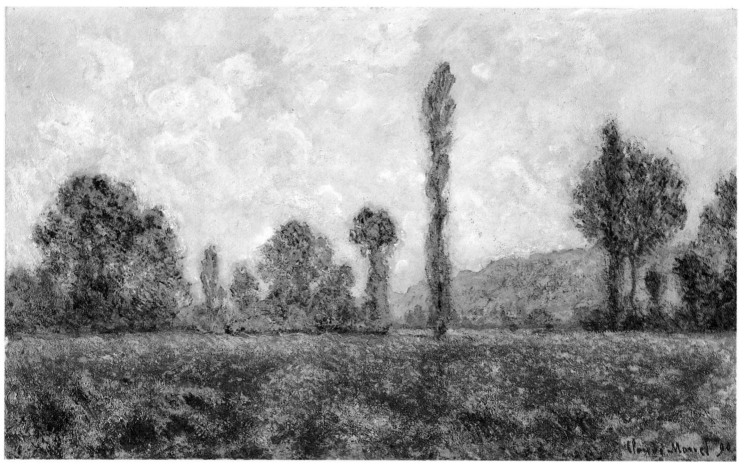

*Poppy Field. 1890*

'I only saw the appearance of objects
as offered to me by the universe
in order to bear witness to it with my brush.
Certainly, that is something.'

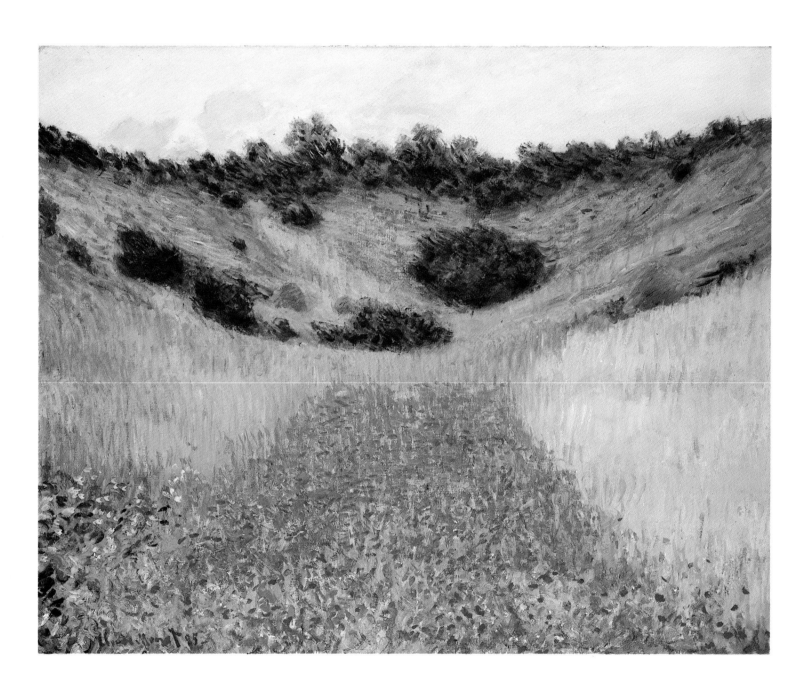

*Poppy Field in a Valley near Giverny. 1885*

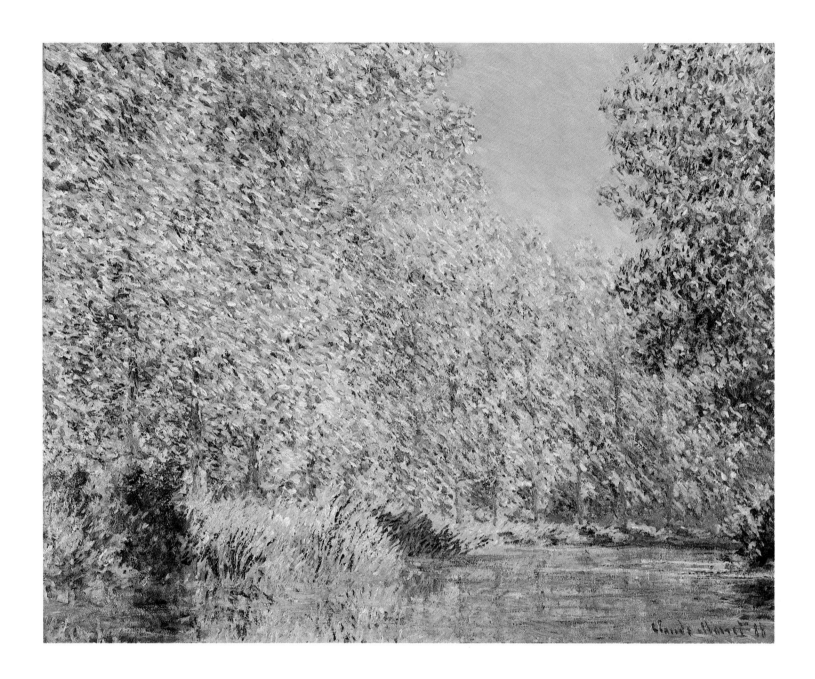

*A Bend in the Epte near Giverny. 1888*

captured by an energetic fringe of dense shrubbery on the near high horizon; above it is a small strip of sunny, yellowish sky. This, certainly, is a pleasing lesson in perspective.

Light, as long as it has strength in this hollow, rests evenly on the inclined plains. Only the atmosphere of an advancing thunderstorm would affect a change of scene here, but Monet does not have this in mind. The storms on the Normandy coast, and the even more violent ones on the Atlantic, were a challenge to him, but the poplars and shrubs in the summer wind are not. The shape and essence of a tree are not what is important, but the light and shade between the leaves, the blue air, shimmering heat, the dissolution of shape translated into short brush strokes, which flit staccato-fashion across the surface of the canvas without slipping away from the parsimony or the canon of their creator for even one moment: these are confident brush strokes borne of the moment and yet of a great sensitivity.

This is what gives these pictures, now being created in a sort of serial production, a value in their own right and what holds the painter's lasting fascination. Wild and accidental as they are out there in the uncertain surroundings of the meadows by the Epte and the Seine, they are preparing the way for the undisrupted creation of the water lily pictures. The 'bobble hat' haystacks and the trunks of the poplars that reach for the sky are then replaced by islands resting in still water, bearing flowers on their grave green leaves, and at the same time symbolising the unreachable.

## Poplars

In the year 1890, Monet turns his attention to the row of poplars that stand on the riverbanks and follow the narrow, meandering course of the river Epte, which is unnavigable by boat, swinging their crowns in the sky above branchless, straight trunks. While his own garden flourishes, the painter is preoccupied with a bizarre subject of such extreme barrenness that it could have proved the undoing of another, lesser artist: three or four columnar tree trunks, with hardly any foliage clinging to them and dancing around them, jut out of the coarse meadow grass above the narrow water course and push against the upper edge of the picture. There is almost no movement in this subject; at times the trees are bluish dark, at times flamingly bright against the deep blue of the sky, through which more distant crowns of trees are lost in a delicate arch in the depths of the picture.

*Colour plates pp 64–66*

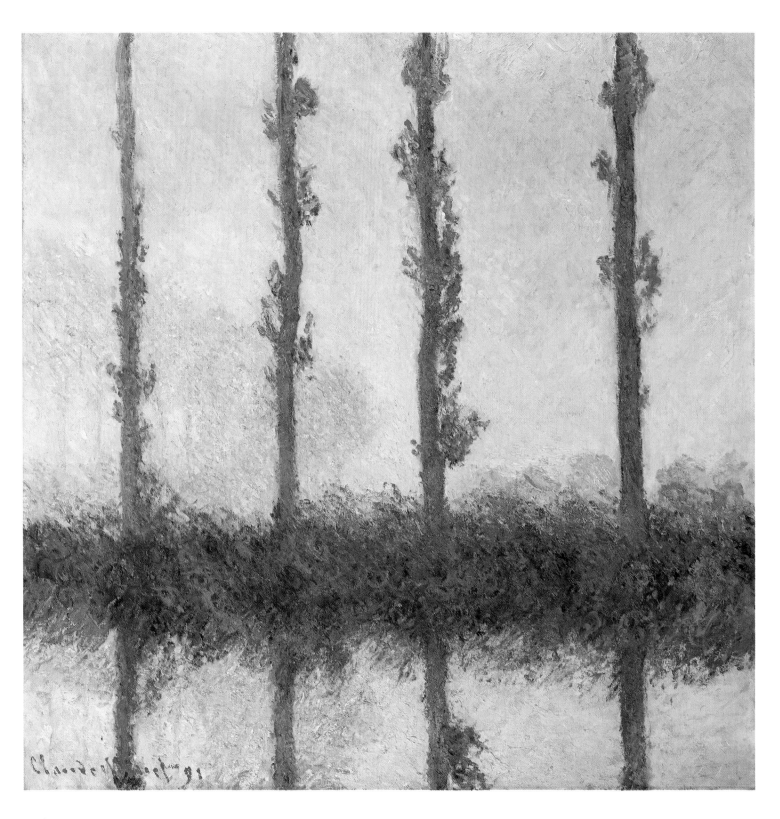

*Poplars. 1891*

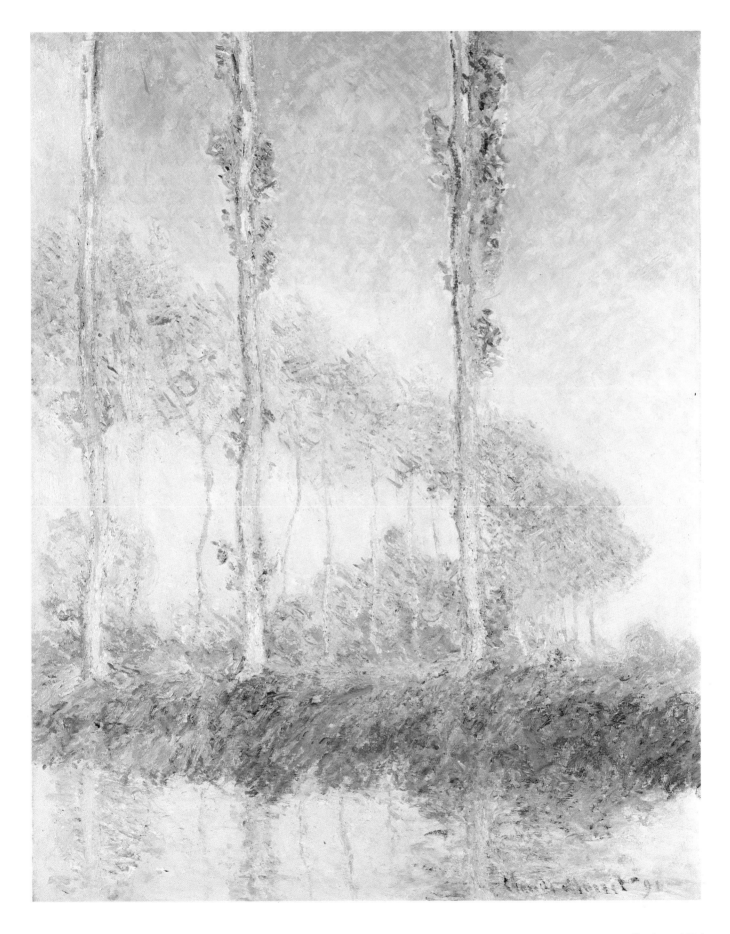

*Poplars. 1891*

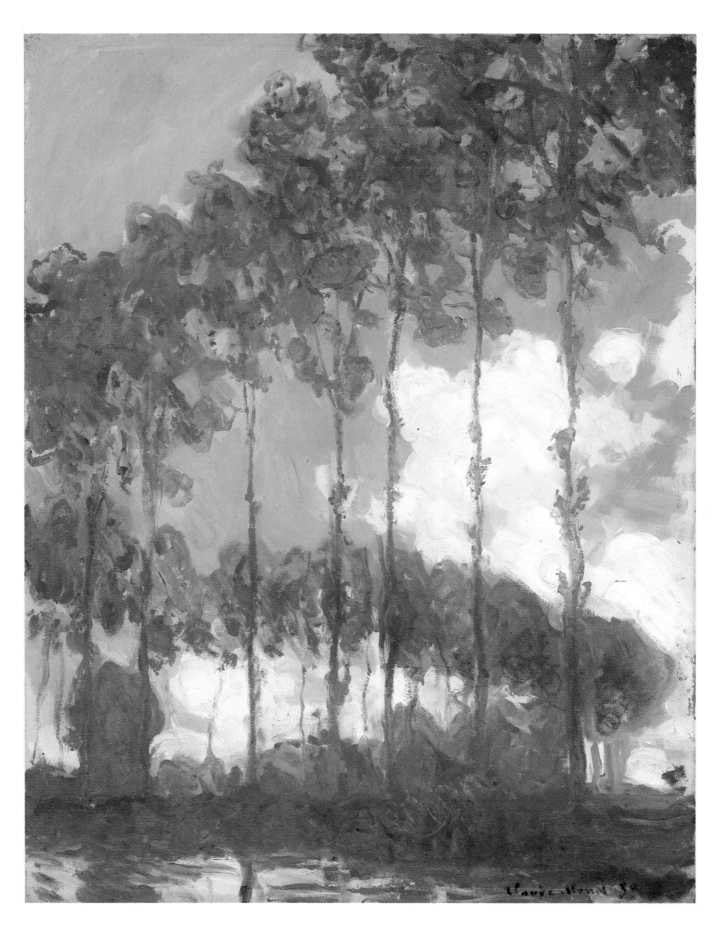

*Poplars on the Epte. 1890*

Here, on these narrow, high-soaring, lance-like shafts, their leafy fans seemingly glued onto the tree trunks, the overall subject is struck: formative sunlight. The coloration extends from a shimmering, whitish yellow to a determined blue silhouette. The river banks, mirrored by the Epte, are luxuriously duplicated and, in the same way, the sky and the large, determining vertical trees return again, with more movement than before. But the peculiar magic of all these pictures lies in the lack of any kind of black; a dark violet and blue create darkness.

Monet made use of this Impressionist 'invention' until his last days, not least because it raises art above the dullness of the Here and Now, above all that is mortal and lifeless. (Even in the 'cool' picture versions of the western façade of Rouen cathedral, the large area of shadow in the sunken window above the main portal is filled with a powerful blue.)

These pictures were soon to delight an audience whose perceptions had become transformed. The acceptance of these paintings into art collections, where through changing times they have maintained their intellectual status to the present day, testifies to the validity of Monet's decision to sacrifice the 'landscape painter' to the systematist. By turning towards the single subject – which submits to his apparent arbitrariness – he renders quantity and diversity within a single picture dispensable.

## Haystacks

There are very many haystacks paintings, in summer and in winter, 'burned' in warm and in cold tones[13]. At times, Monet moves close to them so that the edge of the picture cuts into their rounded shapes; at times he captures them from a distance, with his easel in the depths of the meadow, placing them in front of a backdrop of trees or a distant landscape – as squatting 'individuals' – in ever newly invented pictures. He thus raises the simplest of all possible subjects to an elevated rank.

Usually the light comes from behind the stacks and dances around their round, cosy shapes, cloaking them in glowing colours. The shadow falls towards the viewer head-on or slightly to one side, markedly cooler on the ground than in the hay, which seems coppery, like dying embers, in the winter pictures with their varied delicate blue-violet shadows, and like a red-coloured heat in summer when the surrounding vegetation threatens to go up in a yellow prairie fire: in between are all the colours of the spectrum, ranging

[13] Fifteen pictures of haystacks were exhibited in Paris in the year of their creation alone, and were sold immediately.

*Colour plates pp 68, 69, 71*

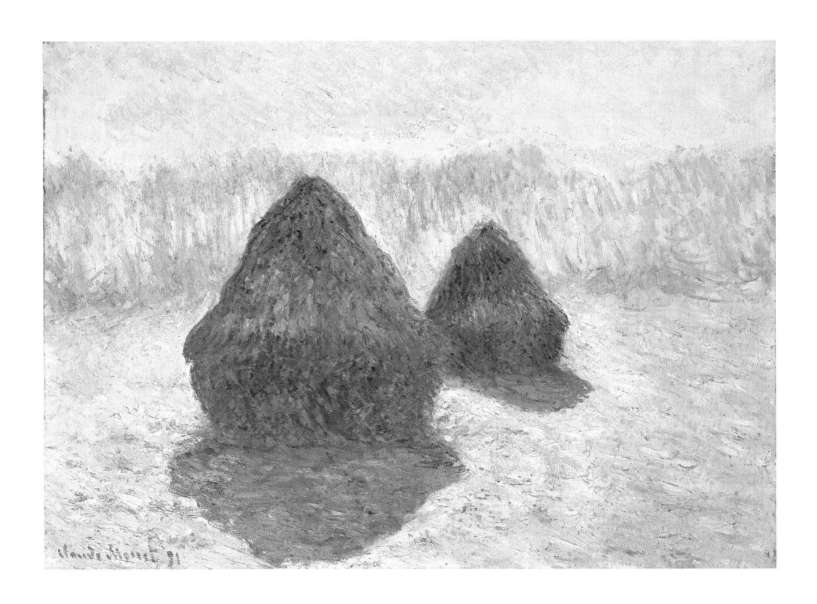

*Haystacks in the Snow. 1891*

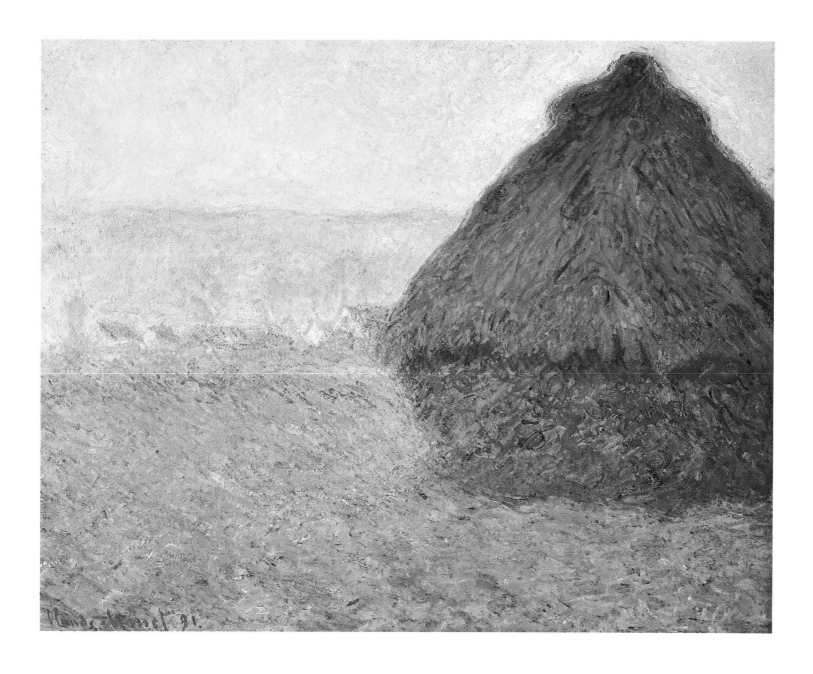

*Haystacks at Sunset. 1891*

14 Wilhelm Pinder, *Das Problem der Generation,* Munich 1926

from 'warm' to 'cold' in temperature, in bluish, flitting, muted and half-concealed brush strokes[14].

Colours, unmixed before being applied, are made to play ensemble only once they reach the canvas, furiously, with the 'key' decided each time: sunset, morning, cold midday, hot afternoon and indeed even shorter time spans: hours, moments. This is how Monet achieves his artistic separation from any given subject.

These exercises in the landscape lead to new objectives. They give us no hint that, at the same time, at *Le Pressoir,* Monet is busily creating an entire flora, translating his painterly ideas into horticultural reality with absolute certainty, while elsewhere in the fields he has to barter for a simple round haystack to be left standing for a while longer.

A wreath of anecdotes winds itself around the creation of the haystack paintings, more to do with agility than with art. It is easy to believe that young Blanche, Monet's faithful companion who herself has started to paint, passed him one fresh piece of canvas after another so that he could capture each impression before it changed into the next.

What Monet has in mind is very hard work: the eternal struggle with the fleeting moment, with time, with the ever-changing position of the sun and the shades it casts. The brush has to follow what the eye takes in with absolute certainty, without becoming distracted by other considerations or cursory in its execution. The haystack stands as if on fire and comes perilously close in the evening sun, its tips glowing in the light; yet, if the houses of the village – bright yellow in the distance, at the end of the meadows – are more a memory than actually discernible, then it shows that Monet has grown experienced in 'outwitting time'.

*Colour plate p 69*

*Colour plate p 71*

In his painting of the year 1893, 'Haystacks in a Field', a meadow landscape spreads out around the rosy, sunny, truncated cones of the haystacks: trees with strong short trunks traverse the plane of the picture, densely packed; in the midday light they cast a brief shadow whose greens are in clear contrast with the silvery violet of the foliage. In the background a second meadow is discernible, lit up between the trunks, dotted with haystacks which are framed by the violet foliage.

This is a picture that contains all of Pointillism without being committed to its rigidity; for the grass tips in the meadows suggest ebbing movement, the scent of summer. If one were to isolate and examine a few square centimetres (inches) of the painted area – as has been done with Monet's paintings[15] – scientifically studying the application of colour, then the extremely artful density of the brush strokes, half-concealing themselves, would become

15 Robert Herbert, Method and Meaning in Monet, in: *Art in America,* Sept 1979, p 90 ff

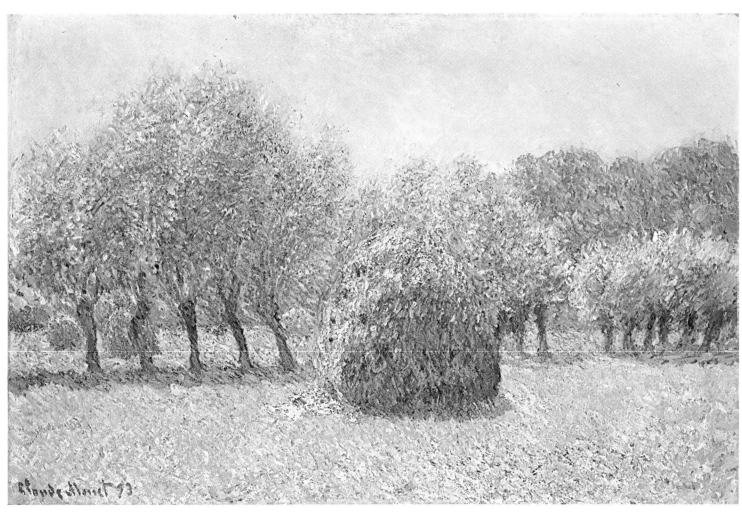

*Haystacks in a Field. 1893*

'I have always detested theories. My only merit
consisted of having worked in the middle of nature and,
while doing so, I have always attempted to capture our impressions,
even in their most fleeting shapes.'

apparent; the first ones filling the 'hollows' of the now much rougher canvases, and those that were applied last adhering to all the raised areas. It is only together that these brush strokes succeed in creating the impression of the vegetation gently vibrating under the high sun.

## The Seine in the morning light

The paintings of the morning hours on the Seine, prosaically called *motifs matinaux* in French, make it apparent how far the poetic realm of the 'narrowed down' landscape – still open nature – has been sublimated on the canvas, creating the most delicate 'mood' without bordering on the elegiac. The fact that later visitors to Giverny, for example Pierre Bonnard and Marcel Proust, fell silent and stopped in front of these works, finding themselves in their own picture and word reveries, was only one of the many effects that transcended mere contemplation to the realms of inspiration.

Monet paints here, on the water of one of the branches of the Seine, in the profound solitude and silence of the morning: massed concentrations of trees rise as a cloud into the tinted sky and surround the wide waters. Because Monet chooses his position virtually under their branches, the part closest to him is cut off by the upper edge of the picture.

Reaching out across the water, the trees – which the mirror-smooth surface of the river supplements with their swinging opposites as if in an ingenious ink-blot image, the light playing about them, the horizon approximately at half height in the picture – take on a colourful fullness, undisrupted by details: no dead branch, no passing water bird, not even the concentric ripples of a leaping fish. The darkness of night – blue night – is still nesting close to the bank and deepens again in faithful reflection in the water, which, softly moving, redraws the section of the sky. Here few bright strokes of colour reach from light to dark: there is not one superfluous brush stroke. What immense concentration was necessary to avoid amalgamating the individual phases of the awakening morning? And how much grinding of teeth when Monet was forced to give up because of a sudden change in the weather! How much futility then is concealed behind the tranquil glamour of the 'timeless beauty', the perfect 'reverie'?

Contemporary reports have given graphic descriptions of the obstacles involved, but they were only concerned with the external circumstances of the painter *en plein air*, risks Monet had long been familiar with. The fact

that it is the observer's right not to wish nor need to know about the adversities involved in their creation when looking at paintings such as these, was later displayed by Bonnard's life's work, of which there is little to tell and whose eloquence has remained his art itself.

## Painting on the water – the floating studio

As if by themselves, the morning subjects create an image of the painter on the water. His studio boat, built by the expert Caillebotte in his small shipyard, has – despite several faithfully annotated pictures devoted by Monet to his indispensable floating painting room – best been represented by Edouard Manet, showing Monet and Camille tenderly covered by the protective sun roof. This masterpiece, created in 1874, a few years before Manet's death, is more concrete and 'human' than Monet's pictures, and a great document of an era of seemingly carefree bohemia on the Seine, of a summery delight in leisure and 'useless activity'. Monet, then 34 years old, paints on the river at Argenteuil: this portrait of his whole stature, seen above the water, shows him sporting a short Van Dyke beard, a pot-like straw hat on his head, a white, billowing shirt, black tie, light trousers, and paying his strict attention towards his subject – a hint of which is already visible on the canvas. The boat, with its light blue half-cabin that continues as a veranda with a curved awning, its fixed rudder plunging sideways into the water, comes across as a successful improvisation, adequate for Monet to be 'at home' on the water of this river so beloved by artists, who bring it to life in summer and in winter – if they are winter-hardy like Monet.

*Illus. p 76*

Unlike the houseboat on which Charles Daubigny travelled the rivers of France to paint the landscapes on their banks, Monet's floating studio was not destined to make greater journeys. For him it is an empty, restful place for his work in which water again and again forms the foreground. It is also a refuge where not a single word is spoken or permitted while he is working on a picture.

*Colour plate p 32*

Manet has not really created a *plein air* picture here – in the same way that he keeps a cautious distance from the young Impressionists on the other bank of the Seine at Argenteuil. The banks are close enough to touch, the black darkness of the boat's body rests weightily in the water. His beautiful 'Manet black' reaches up to Camille's little hat. A summer picture, it is called 'The Barque' by agreement, and shows the painter in the open air, rather than the

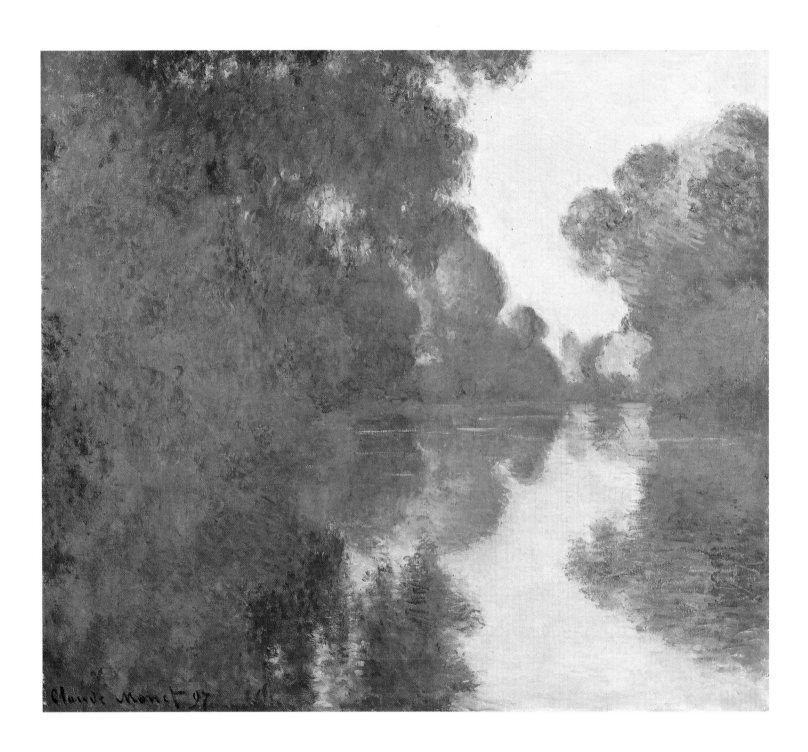

*Morning on the Seine near Giverny. 1897*

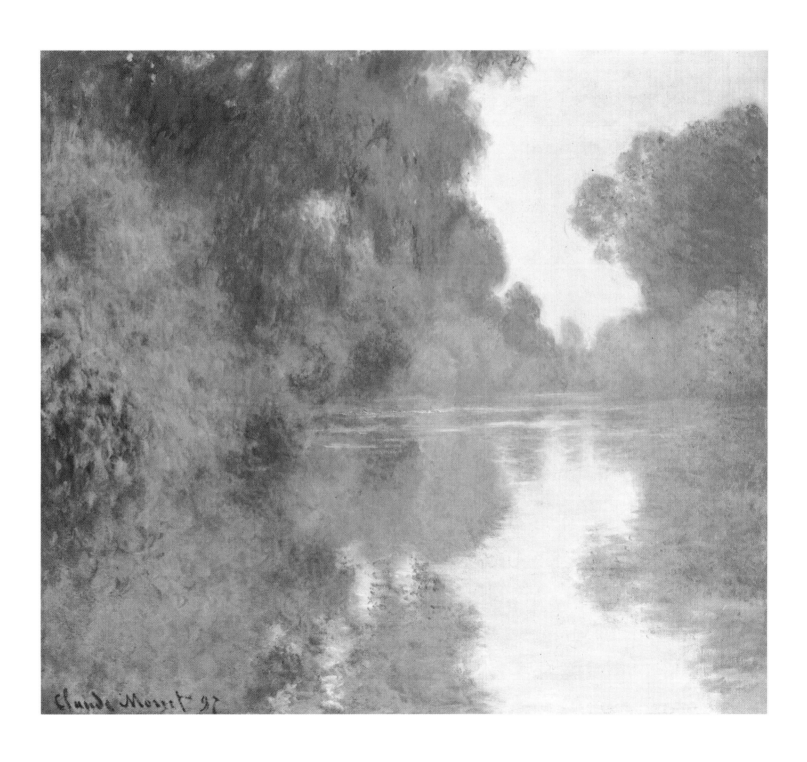

*Branch of the Seine near Giverny. 1897*

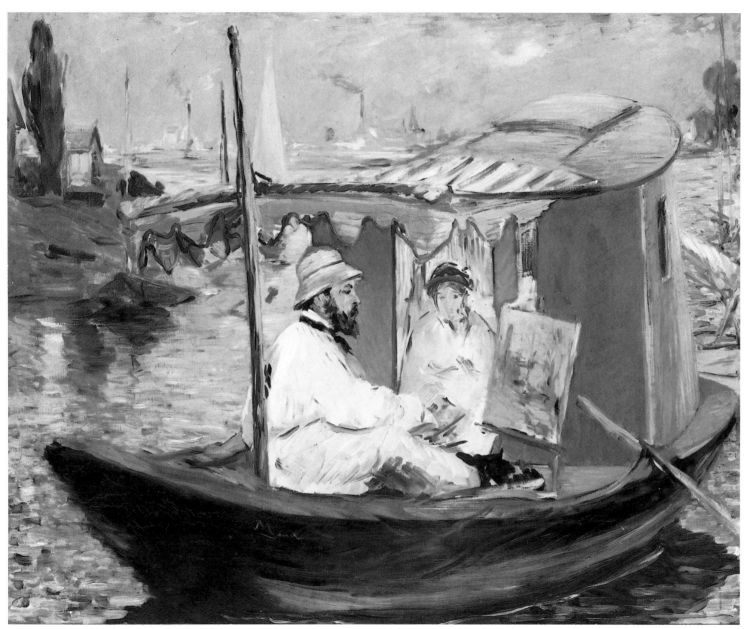

*Edouard Manet, 'The Barque' (Monet at work on his studio boat with Camille). 1874. Oil on canvas, 80 x 89 cm (31 ½ x 35 in). Munich, Bayerische Staatsgemäldesammlungen, Neue Pinakothek*

open-air painter, which is how Monet sees himself in his years at Giverny up to a ripe old age.

It is said that this boat, together with the *Norvégienne*, which were moored at the small island in the Seine, with a shelter for winter, served the large family for many other delights: for bathing parties and small excursions, for life on the water – the attractions of which appealed to everyone at *Le Pressoir*.

Monet was always attracted by water and spent many happy hours in its company: on the Seine, the Epte, on the Thames in London, on the canals of Holland and Venice. He created his water garden, with a pond fed by the little stream of the Ru, as his own delimited water realm: a logical thing to do. The guest on the water turns into the landlord on the lake. He did not have to be miserly in the process. His diligence and persistence, which helped him conquer a new vision in the meadows, bore fruit; friendly Parisian art dealers are now no longer only sharing his table for lunch.

'Monet is no more than an eye,
but, by God, what an eye!'
Paul Cézanne

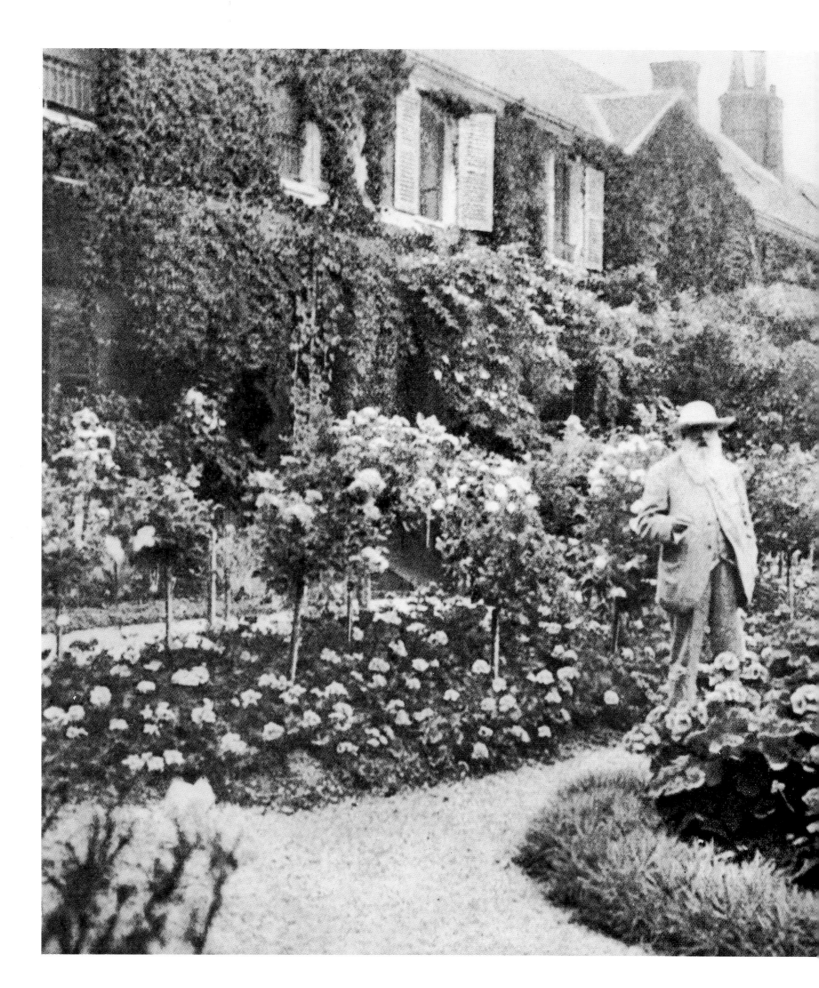

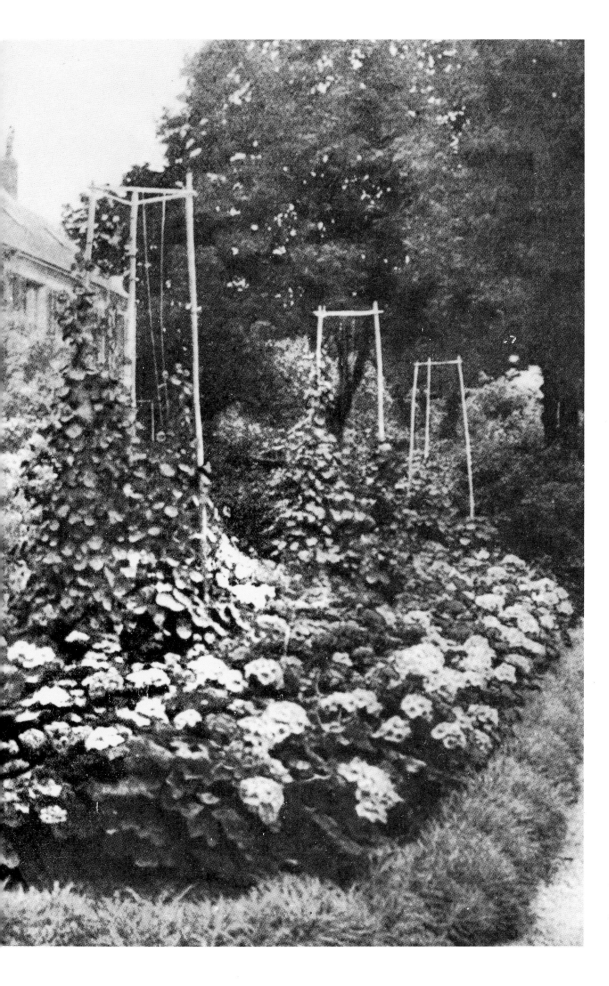

*Monet in his garden in high summer, surrounded by carnations, geraniums and canna, ca 1922. Collection Durand-Ruel, Paris*

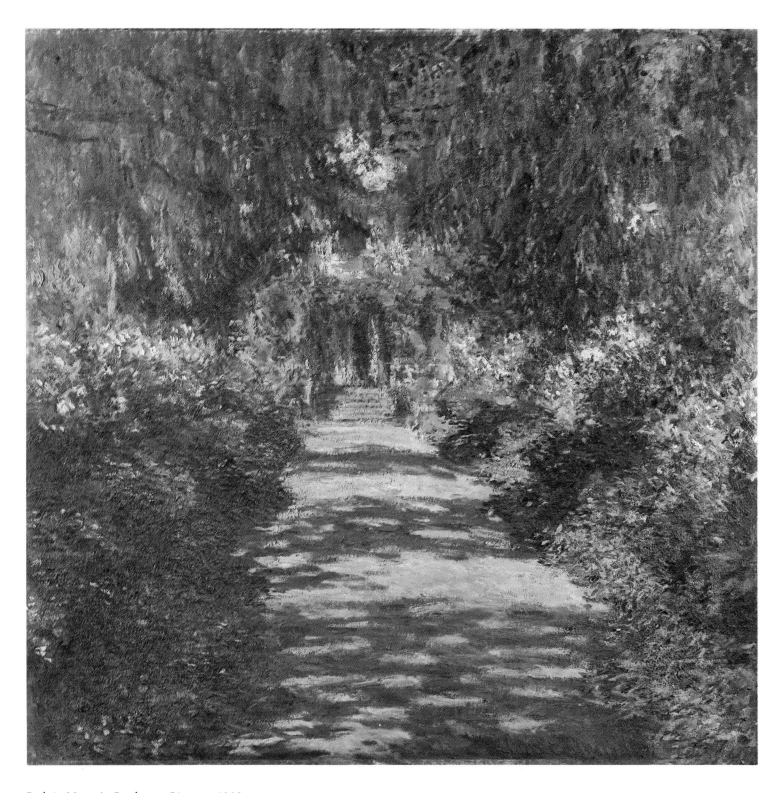

*Path in Monet's Garden at Giverny. 1902*

# The painter and his gardens

In his autobiographical writings[16], contemplating gardens that, from 1800, have suffered ruination to satisfy the fashions of the time, the German poet Eichendorff remarks: 'Every true garden, however, Tieck[17] somehow quite rightly remarks, is fashioned by its unique location and surroundings, has to be an attractive entity, and can exist only once.'

[16] Joseph von Eichendorff (1788 Schloss Lubowitz/Upper Silesia – 1857 Neiße), *Werke*, Munich 1981, vol IV, p. 1501
[17] Ludwig Tieck (1773 Berlin – 1853 *ibidem*), German poet and translator

## The Clos Normand

Monet turned the *Clos Normand*, which he found as a barren area sparsely stocked with apple trees, into just such an 'entity', initially sensing rather than knowing what a painfully long time it would take to train nature to respond to this transformation. It was a path of patience and persuasion – even with his family, who could contribute no more than good will to his passionate ideas – which led from the main path, flanked by evergreens, down to the road and the rail tracks, to flowers cascading over one another; from overgrown pine-tree stumps that were meant to rot away, to the metal arches that would allow climbing roses to grow in their own individual way.

The 'beginnings in the field' – wretched plantlets, modest shoots and seedlings beside felled apple trees – create a poor picture. But Monet is drawn towards another 'picture', which so far he only has in his mind: colours instead of green, nature in a state of heightened development, favourite hues instead of a riot of colours.

His eye for design – which we will discuss in greater detail later[18] – is complemented by an eagerness and willingness to learn. In nurseries, in his discussions with the experienced and passionate gardener and friedn Caillebotte, and later in talks with the head gardener Breuil, he acquires the knowledge that will ensure the lasting beauty of the garden: how he can make it flourish again in the spring, after the inclemency of winter, by keeping the plants in the greenhouse, out of the Normandy cold.

[18] Cf contribution by Herbert Keller, p 143 ff

*The main path after reconstruction*
*The main path with the two yews, half-concealing the house. Collection Country Life Magazine*

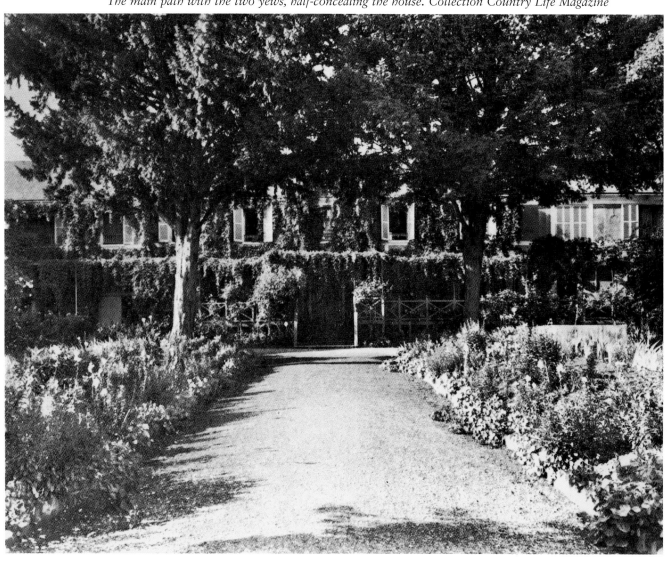

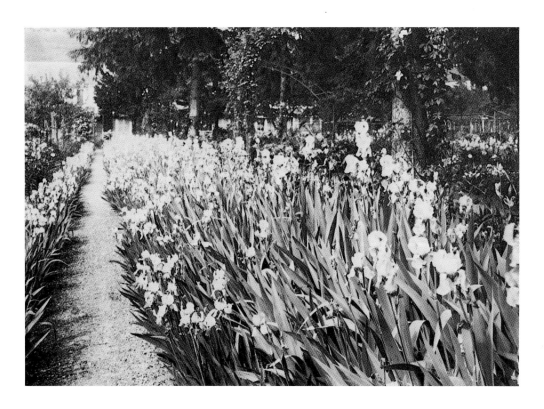

*Irises lining a path that leads*
*towards the house.*
*Collection Truffaut, Paris*

The accidental, as it is produced by the meadows and the *marais*, in a brief, wild luxuriance in early summer, no longer has a place in the garden. Controlled growth and development are the aims here. Not even the dogs are allowed to rummage and roam freely in the garden, where Monet, wandering about in the first early hours of the day, is already inspired to paint. We can guess from his endlessly renewed delight when he returns from one of his painting journeys, and from the worries, questions and advice he puts in his letters from afar, what the *Clos Normand* must have meant to Monet even then. He ponders about individual flowers and plants, is filled with consternation when a storm causes damage, a branch has broken off, devastation appears, when the 'picturesque' image of an area he has chosen to paint has been destroyed or changed.

It will be easiest for an aesthete who lives with a garden in which he has invested affection and who seemingly gets a response from his flowers, to judge how much more intense the artistic inspirations and sensations become for a painter of Monet's rank in this garden. It is not, however, surpassing nature in the fields that becomes his subject now, but rather – as on the Seine and the Epte – the harmony of colours, now of course much fuller and denser, from the ground to the heights, captured and reflected by the sonorous darkness

*Illus. p 82*

'My garden is my work,
created slowly and with never-
diminishing love, and I do not
deny that I am proud of it.
Forty years ago, when I first
arrived here, there was
only a farm and a sparse fruit
orchard. I bought the house,
enlarged it and, bit by bit,
designed it to suit my own needs.
I dug the soil, planted,
pulled out the weeds, and
in the evening the children
watered the garden.'

*Monet's Garden in Giverny. 1895*

of the two yews left standing by the central staircase of the house. And there can only be bright, glowing-yellow or deep-violet 'cushions' on the ground, and above them red and pink, white and pale blue flower dots, which – combined most densely around the barely visible main entrance – determine the colour design of the picture in this extravagant 'lesson' that reaches far beyond nature's model. He is gripped neither by the perspectives nor by the buildings in the garden; neither by topographical accuracy nor by a pleasing picture narrative: the *Clos Normand*, this *hortus conclusus* (enclosed garden) created as planned, becomes art: a timeless creation.

*Colour plate p 80*

And thus no flowers can be 'read' here, nor interpreted or determined, where only botanical knowledge would be able to place labels. Light paints the garden path, and blue-violet shadows arrange themselves around it as if the flowers are pouring themselves out over the ground. The last pictures will flood into veritable colour symphonies. Irises, which he planted – and later had planted – in long field-like strips, are still the easiest to recognise, their flower heads combining a darker, fuller and a paler violet. These 'flower ribbons', proof of Monet's 'accuracy', broadly traverse his canvases, following the diagonal lines of his garden paths, although he is not a 'painter of flowers'.

*Colour plate p 142*
*Colour plates pp 140, 141*

*Illus. p 83*

Here already, it becomes apparent that Monet is not interested in the 'literal'. While he is painting, a different sort of garden emerges, forever flowering and free of rain or storm ; where no branches or leaves ever litter the paths; and where the sand and pebbles are quite untypical of the local Normandy soil. Yet despite all these deliberate transformations, the 'firm grounding' in the garden still survives.

## *The water garden*

Poetry is now all-powerful; the colours have been decided, even if they have to combine and become a unit from the smallest particles. Of course the pictures of the flower garden, its considerable size making it large enough to permit and even demand lawn areas, are ingenious studies for a new idea that is beginning to take shape: the water garden.

*Illus. p 90/91*

And it is telling that Giverny's lasting and enduring fame is founded entirely on the creation of this water garden. To reach out across the road and the railway track into the boggy water meadows, to add a pond to the maturing garden, which gently slopes to the south, and thus to enter an even higher region: that is the painter's ultimate aim.

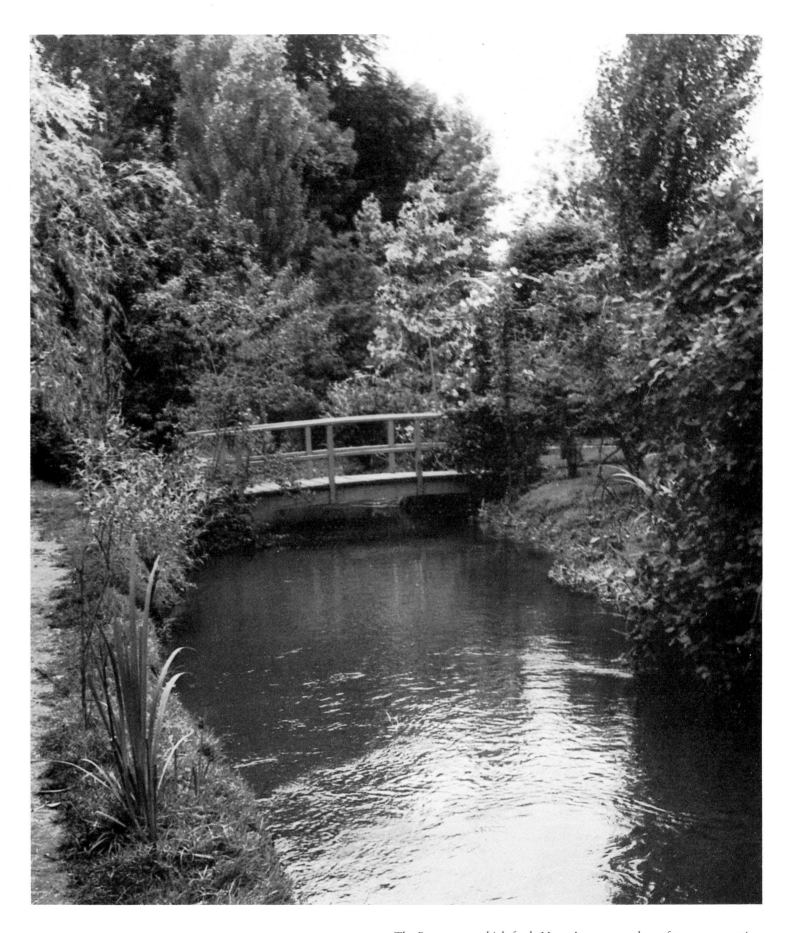

*The Ru stream, which feeds Monet's water garden, after reconstruction*

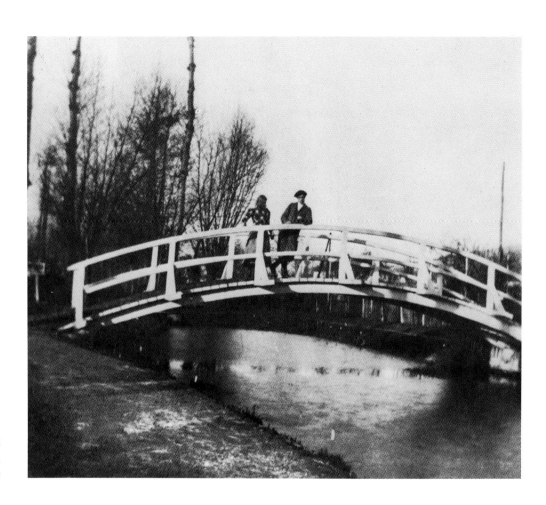

*Michel Monet and Anna Bergman
on the Japanese bridge.
Collection Piguet, Paris*

*Illus. p 122*

There are hints of all the ploys and deviations needed to reach this aim. They are our surest proof of Monet's single-mindedness, even if his patience was sorely tested this time; for, apart from all the difficulties – at the time considerable – connected with his plan of diverting a stream in order to feed a strange, 'nonsensical' pond, he had to deal with the ruses of the local farmers: foreign plants in the pond might poison the cattle grazing below Monet's painter-garden near the Ru and the Epte.

The size of the water garden, left vague in Monet's paintings, might come as a disappointment for today's visitor to Giverny. Even so, it was fairly impressive. Photographs from the earliest days show it still barren and lacking any shapely contours. The Japanese-style pedestrian bridge, as yet without its metal framework for the wisterias – which was only added in 1910 – has to create the effect. This bridge, too, with its delicately curved arch mirroring those in Hiroshige's coloured woodcuts, is 'crazy' in the villagers' eyes. Even so, it had been destined from the very beginning – along with assorted other

small bridges – to admit a path for strolling around the pear-shaped pond that was to make history. The ensemble is devoid of playfulness but follows Monet's vision: he wanted to incorporate the liveliness of water into the realm of his garden, without having a stream running through it. This is why the pond was to be fed only occasionally, by locks. The entirely plausible simplicity of the irrigation method is soon overtaken by artistic considerations, which lead to the banks being planted up, giving them an exquisite richness described in contemporary accounts.

Even if the people photographed on the Japanese bridge – a curiosity spanning naked embankments – still seem forlorn in these early days, Monet, experienced as he is, thinks beyond this stage, to the 'Nymphaeum': even though, one day, he self-deprecatingly said: *'J'ai pris un catalogue et j'ai fait choix au petit bonheur, voilà tout.'* ('I took a catalogue and chose off the top of my head, that's all.')[19] There were questions to be asked about the plants' growth habits and tolerances; the planting in areas of light and shade had already been considered, as had the shape of the pond: grasses on the banks, wisterias and weeping willows added to the existing trees along the edge of the *marais* – which Monet had drained – with vistas through them and a place for mooring the boat. All this had been devised as a decorative overall picture right from the beginning, rather than one that was continually and belatedly enlarged and evolving.

The meadow stream Ru, which branches off the Epte for a short distance, becomes – according to Monet's plan – the water donor, gently flowing beside the pond, it too lined by ornamental grasses and water plants, and overhung by the branches of an ornamental cherry: itself a motif within the water garden. What a stroke of luck!

The idyll is magnificent: willows and poplars add height, rhododendron bushes flower in partial shade as well as in full sun, large and small-leaved plants intensify the concentration of colourful blooms in this lush, early-summer scene and irises are iridescent next to the narrow paths, which Monet has walked many times with his visitors, proud of this second creation of his, after his paintings.

The harmonious interplay of colours and plants that he has planned – plants which are from now on always 'kept in readiness' for his painterly visions by the gardeners andd assistants under Breuil's expert supervision – reaches perfection in a water lily pond. With his eyes on the calm, pure and undisturbed water, where the tender-green plates of the lily pads spread out, the crowning of his life's work is finally revealed to him: how he can capture all his experiences of the ever-changing power of light in the sky in one single theme

*Illus. p 88*

[19]Quote from: *Monet à Albi*, exhibition catalogue, Musée Toulouse-Lautrec, Albi, 1975, p 35

*Illus. p 87*

*Overleaf: The water garden. Collection Roger-Viollet, Paris. (Photo: Harlingue-Viollet)*

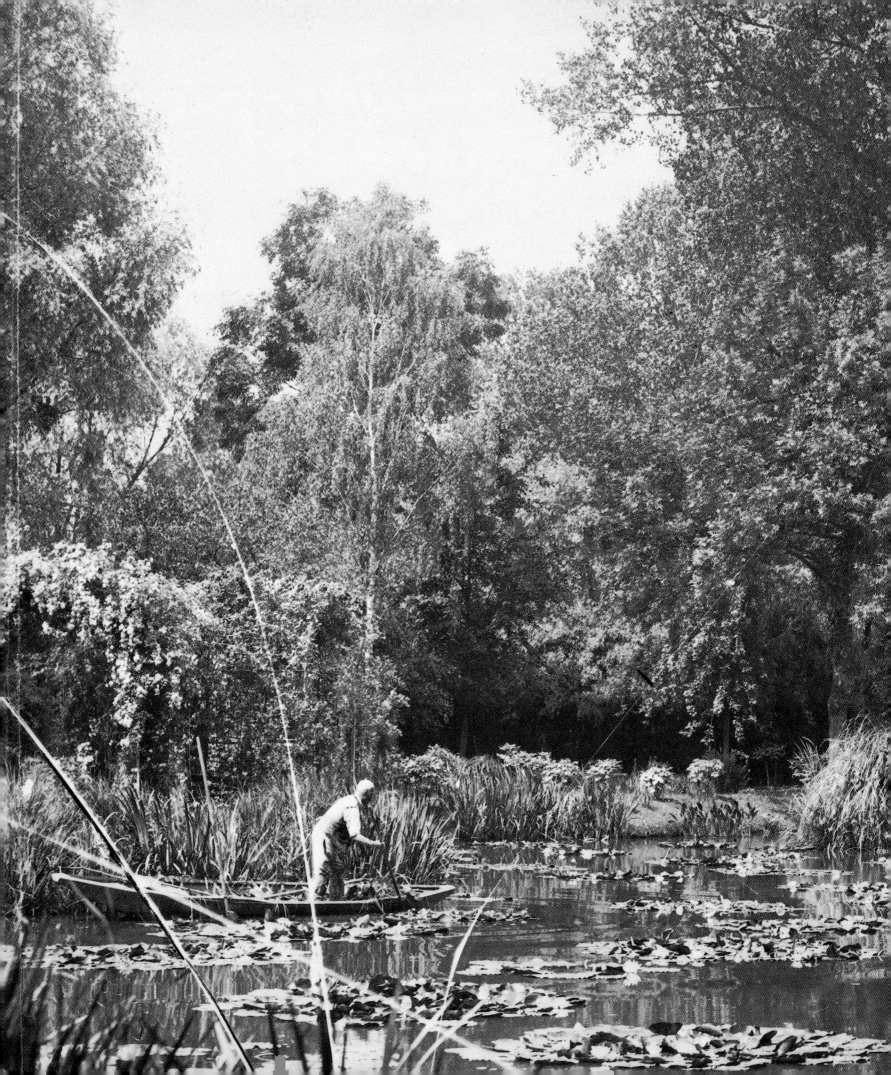

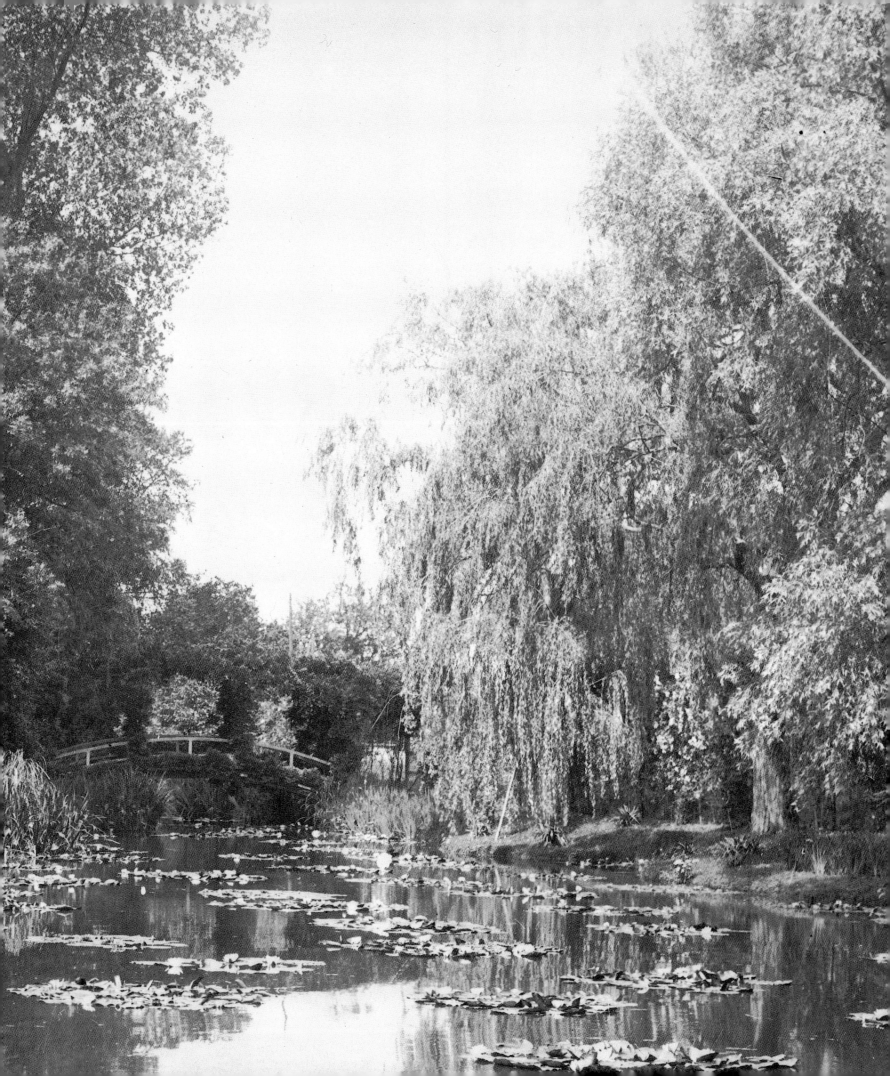

*Colour plates pp 133–136, 137–139*

– in a picture of water lilies. Here the reality of a pond covered in islands of flowers would merge into the other reality of paintings. He began this giant oeuvre, which was to run through various phases, in 1899 and continued working on it for 27 years, even though cataracts threatened to deprive the now 80-year-old artist of his eyesight. (An operation on the right eye restores a passable degree of vision.)

## Orderly beauty

Thus, the *Clos Normand* and the water garden are not a happy accident that spared a brilliant artist, used to painting outdoors, the trouble of venturing out into the countryside. Even today, in the restored garden, we experience the results of the planting and expertise that helped Monet order and arrange his 'garden happiness'. Behind its attractive appearance lies hard work. Similarly, it is only the 'garden fanatics' of his own ilk, strolling through his flourishing grounds with him, who are fully aware of his patience and foresight. He does not have to explain anything to the connoisseurs, and everyone else is full of admiration anyway.

In all that has been written on the subject of 'Monet and Giverny' over the last hundred years, there is no mention of the fact that the master of the garden subjugated the work he created here, his unforgettable artistic work, his painting, to this garden; that he 'contented himself' with what he could oversee and what was 'at hand' as a theme. His canvases do not tell us of the garden in winter nor of the flowers that overwintered in the greenhouse. This is where he drew the line: against all disorder and rampant growth, against uninvited guests or apprenticeship of any kind, against the now noisy village with its invasion of artists and all the imitators following in Monet's shadow. This is where he gruffly drew up the drawbridge to escape into his own 'fortress', away from temptation and confusion.

It also explains why he preferred the simple to the complicated, starting with his table at lunchtime and finishing with the painted rose arch: he had to save abundance from superabundance. A garden in Normandy did not permit subtropical lushness where what is overgrown must suffocate. And what could not survive in this climate – such as the pale blue water lily so beloved by him – was not admitted into his paintings either, not even into those of the last years of his life. Eventually, in his late work, the studies for the 'Nymphaeum' become so detached from the natural form that a translation

*Fern and Japanese azaleas.*
*Collection Truffaut, Paris*

of the colours and forms could even lead to future misinterpretations: Kandinsky, as one, found himself encouraged by such pictures to venture into his art without objects, the surreal, a mistake which surely it is easy to forgive with hindsight.

# Everyday life

The painter only become the *patron* – a title Monet was eventually happy to accept – after many years at Giverny; after being given village honours, commissioning work on the house and garden, draining the *marais* and successfully preventing the factory chimney from being built. His everyday life, which we tend to picture only in the summertime, also knew the winter gloom. His was the withdrawn life of a family who lived in the countryside around the turn of the century, for whom the advent of electricity was a major event during long evenings of readings with guests who were close friends. He experienced changes unconnected with the garden: youthful fun on the waters of the Seine and on the ice in winter; jollity in the only village inn with a growing number of strangers who sought his company, companions who would stay and others who would move on or give up their art for a game of tennis; and eccentric activities like collecting birds' eggs. Some of the young people were driven simply by curiosity, wishing to sneak a glimpse of the artist's garden, where a man usually sat, just as in the days of the Romantics, under a large umbrella in front of his canvas to paint only water lilies – a motif that was and has remained his very own discovery. Nothing else, human or animal, makes an appearance here. Nature alone holds herself in readiness for him, with her noble wealth of plants. Looking back and forwards in time, we fail to find such esotericism and, at the same time, such a claim to power: Monet was only able to achieve this by immersing himself in his art in a way no other artist has done.

When he did nevertheless take time off from his work, he enjoyed harmless amusements: small pleasure trips on the Seine, collecting mushrooms in a distant wood beyond the river – always in the fashion of the time; with the utmost simplicity and with a certain charming laboriousness typical of that era; with a picnic and companions who exhibited a finely balanced mixture of respect and impudence. Sacrifices were neither sought nor made. According to reports from those closest to him, the amount of time that Monet set aside for his family was agreed freely, without suppressing any temperaments or controlling inclinations. The youngest and the oldest in his circle were well

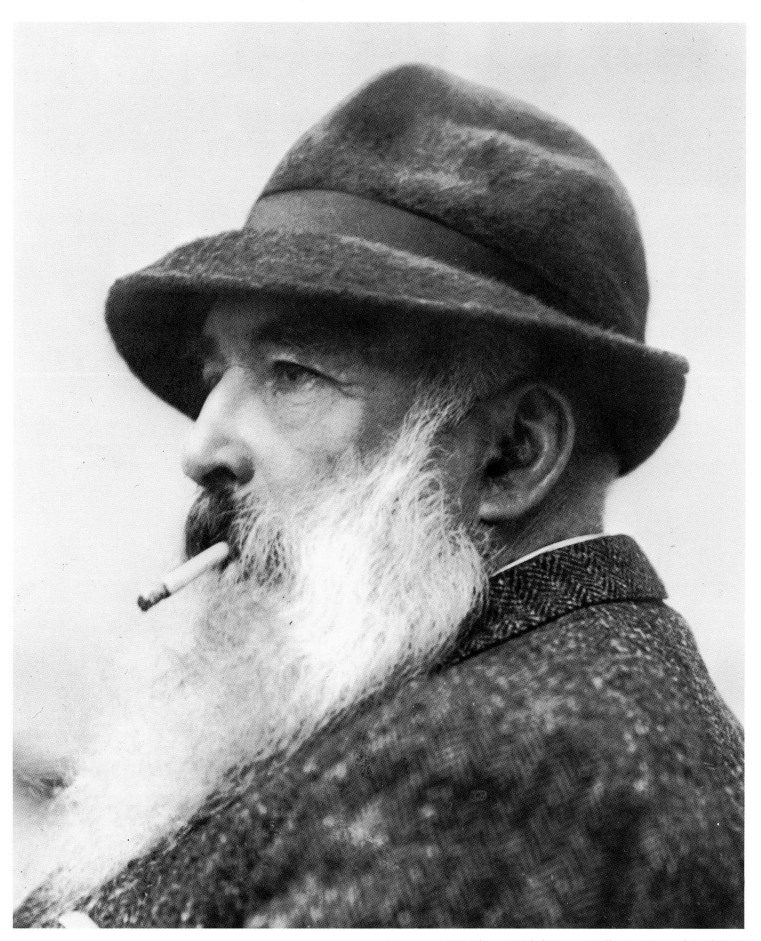

*Monet ca 1920. Photo: Michel Monet. Collection Durand-Ruel, Paris*

aware of the respect that was expected; the exact delineation between what was permitted and what was demanded until he had amused himself sufficiently, all of which benefited *Le Pressoir*.

If this had not been the case, the story of the garden at Giverny, how it managed to survive all future perils – which lasted for decades after Monet's death – and how it was eventually restored, would be entirely incomprehensible. This spirit of balance and respect lived on through the years of profound oblivion, through times of raging war, while the fame and reputation of the gardens and their creator were temporarily lost to memory and clear notices had to be erected to keep the unsuspecting stranger away from the paradise that was now running wild.

## Welcome guests – desirable distractions

*Illus. p 97*

*Illus. p 98*

20 Claude Monet – Les Nymphéas, Paris 1928

*Illus. p 120*

Visitors who wished to see Monet's paintings and to try their hand at collecting them were desirable distractions and high points in this hospitable house. Georges Clemenceau, then the leading French statesman as well as a friend of Monet's, was a regular and welcome guest; Cézanne and Renoir sat at the table here and strolled through the garden; Pissarro and Sargent, as well as Geffroy, the critic, future friend and biographer, had gained the right to hospitality. All of this clearly indicates that conversations were initially kindled by the garden, but then ended with art (Clemenceau also wrote about the *jardin d'eau* [water garden][20]).

The admission of these friends and many other visitors to *Le Pressoir* also ensures the emergence of a host of legends, depriving the village of Giverny of its anonymity once and for all. The first automobiles draw up outside the estate, carrying dignified persons and bringing a never-ending supply of topics for village gossip.

And, indeed, the appearance of Japanese guests – the ladies wearing traditional kimonos – complete the painter's reputation in the village: these enthusiastic collectors of Monet's pictures are even prepared to acquire for their country the entire 'Nymphaeum', which will be completed in the third studio, canvas after canvas, like a never-ending dream in pictures. Nevertheless Monet always remains faithful to himself as well as to his promises to complete the cycle for the Orangerie. We shall not pursue the story of this particular 'commission' any further here because it is already going beyond the real realm of experiences at Giverny.

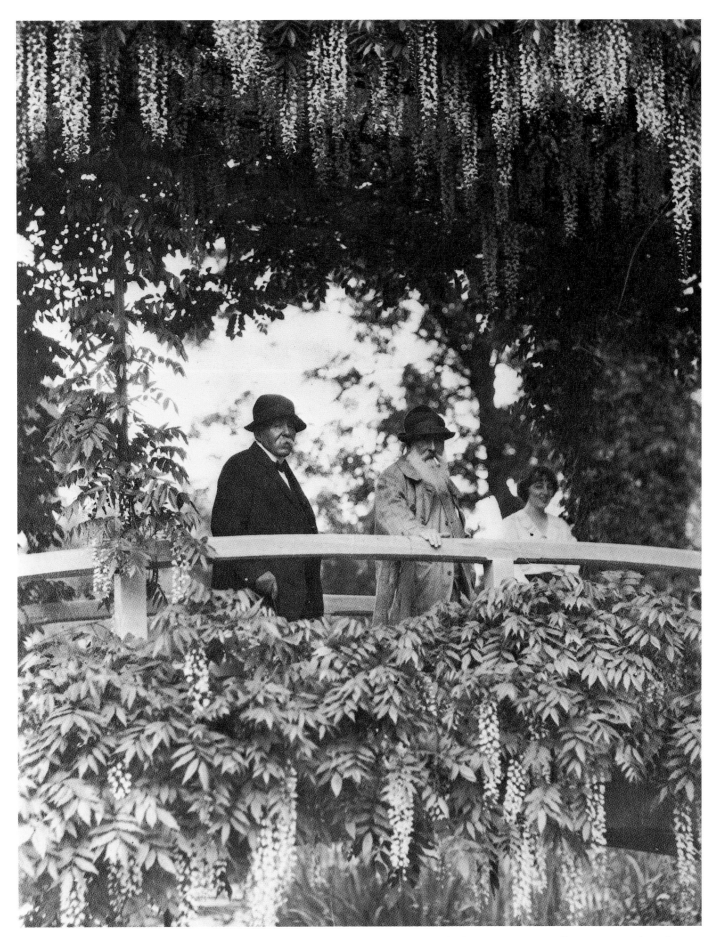

*Georges Clemenceau, Monet and Lili Butler on the Japanese bridge, June 1921. Collection Durand-Ruel, Paris*

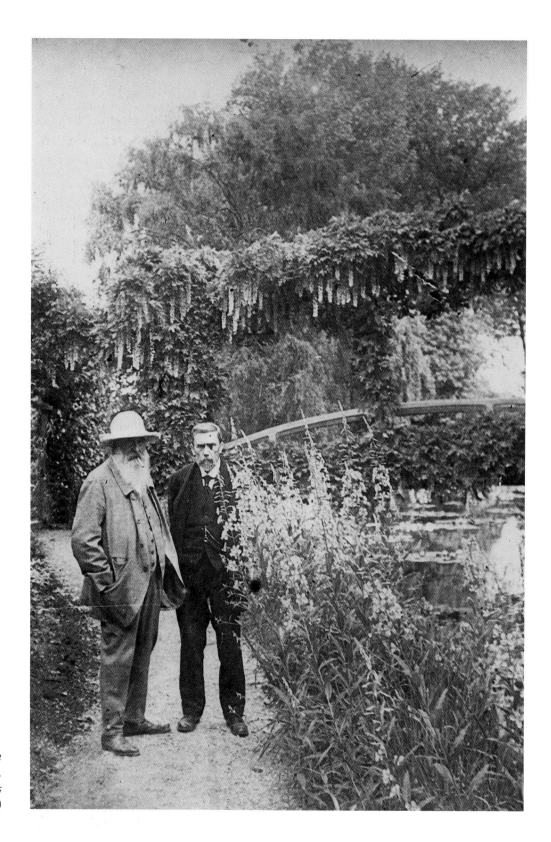

*Monet and Gustave Geffroy in the garden. Photo: Sacha Guitry. Collection Roger-Viollet, Paris (Photo: Harlingue-Viollet)*

## Painting excursions from Giverny

It is part of Monet's image at Giverny that a 'guy' like him, a Norman bitten by the travel bug, could not find satisfaction in this idyll, which was growing ever more perfect; this splendour of flowers and flowering shrubs, of overgrown, scented arches, of *nymphéas* (water lilies), drifting gently on the surface of the water, smooth as glass. He was gripped by a restlessness to explore the rugged and foreign under a different sort of light; to explore north and south in his paintings and to confront the force of impressions which he would conquer with pictures of his visions: *voyages pour peindre*. A dozen times he leaves Giverny, mostly to satisfy his longing to be near moving water, until in the year 1909 in Venice – now almost 70 years old – he is content and finally withdraws to his studies for the 'Nymphaeum'.

In the meantime, the *Clos Normand* and the water garden have long been transferred into his ownership so that the instructions he sends from his journeys refer to his own property. He travels – often in winter – with several canvases, which means that he is not limited to one particular motif at one particular hour in comparable light. The subjects suggest themselves to the experienced open-air painter, who is confident in his judgement of what will work. Here, too, most of the paintings reinforce his beliefs, just as in Giverny, which occupies his mind from afar. His thoughts always return to the garden: from his journeys he writes about the anemones, clematis and peonies, about the orchids in the greenhouse, the dahlias and chrysanthemums; from Norway he returns with plants.

*Illus. p 101*

But then he is in Bordighera and Antibes, in a light to 'drive you insane', completely detached from his garden; on the Atlantic coast on the offshore island of Belle-Ile, surrendering completely to the savagery of the water, the powerful surge of the tides. In 1890, in the valley of the Creuse, in the west of France, he paints gloomy rock ridges above the deeply cut river valley; on his Normandy coast, at times near Dieppe, at times near Fécamp and Etretat, he works by the water and the cliffs – in all weathers.

The London bridges and Venetian palaces that rise out of the water become subjects for him, cloaked in mist, and he turns them into picture celebrities that have never before been seen in this way. Holland's tulip fields and windmills on the canals, and Norway's snow-covered regions attract him. Much that appeals to him – always the landscape, mostly without people – becomes a picture for him, an 'impression' amidst sun or fog, between sunny day and profound twilight, when objects lose their definite shape and dissolve into sparkling colours. The dramatist is happier with such undertakings, where

the strain of heat and cold can be imagined, than the lyricist. The pictures of Belle-Ile, of the grim Creuse Valley, and the studies of Norway in winter too, are all superior to those of Bordighera and Venice: he himself admits a sort of failure here. The freshness – revealed in these paintings by the forces and shapes of nature, and the originality with which he captures them – is characteristic of Monet's being and art. No one before him had painted the surging waves and rocky cliffs like this, not even Courbet. This mastery in translating the purely picturesque into art, in reclaiming graduated colours from a subject where they seem to be sparse, overwhelms even the first viewers when Monet finally decided, urged on by his family, to exhibit the pictures along the walls in the studio at Giverny. Here it became obvious that subjects seen from close up and from afar can withstand the most drastic reinterpretation without becoming unrecognisable.

Although Monet's journeys produced a wealth of paintings which have considerably enriched his *oeuvre*, they also made the ageing Monet aware that he no longer needed the outside world to realise his 'Idea'. His art has succeeded with everything: the structures of what is firm and the pounding of the waves on what is not firm, transparent.

The naïve venture of the youth who wanted to outdo Manet's 'Déjeuner sur l'Herbe' with an extensive costume group under trees – true giants and heroines – and who was helped by friends patiently modelling for him here and there, is now replaced by other insights and objectives: raising colour alone to an intellectual power; drowning the entire canvas with an orderly abundance so that the uppermost layer of colour still allows those colours below to have a say, something the viewer will only be able to perceive when he steps right up close to an original painting to study the creative process, at least what is comprehensible from the surface.

Thus the 'narrative pictures' of 1865, with white-dressed figures in bunched crinolines and dark gentlemen, fashionably fitted out, driving through the garden, become dispensable for Monet, just like any 'model' who, in a staged pose, is turned towards the painter rather than the breakfast feast spread out on the grass.

Monet's work at Giverny benefits from the paintings he creates on his journeys, because these were always done in a new light and a different climate that the painter had to grow used to. Reassured about the way he sees under foreign skies, the comfort of the gardens is experienced with twice the former intensity. Here he has to tolerate neither hotel windows nor the gondolas of Rouen or Venice; neither the easel weighed down with stones near the swell in the Bay of Biscay nor the fought-for position under olive trees above southern

strands: he is in his own realm. We can see it like this: the 'journey paintings' are part of the overall *oeuvre*, but they are also Monet's answer to the questions of the ever-increasing circle of friends who eagerly await his pictures.

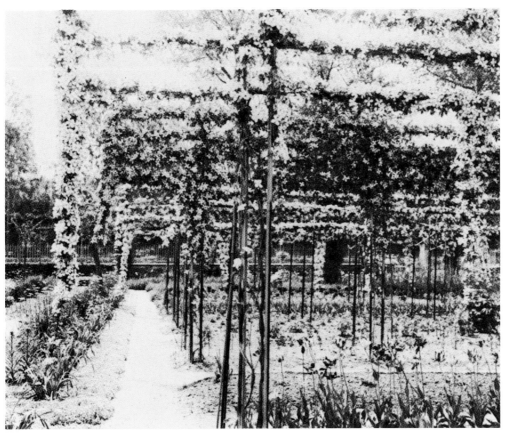

*Tulips and clematis in spring. Collection Truffaut, Paris*

# Garden paintings before Giverny

Gardens and their translation into art are a more lasting preoccupation for Monet than for any other Impressionist. Like water, the world of gardens attracts him; he settled to paint in a landscape of flowers when he was just 25 years old. Mostly portrayed as inanimate, Monet's gardens still breathe the proximity of human beings whose hands control their flowering. The beauty of a garden corner is preserved as it is. He is inspired by small ornamental and residential gardens in full bloom, unfolding in a limited space: nothing spectacular or anything conventional. His subjects are anonymous, in keeping with the spirit of the period. Neither marble nor pruned hedges are required, nor the blue-dark cabbage fields that the painters of Barbizon thought worth portraying, like autumnal leaf fall, dead branches and other characteristics of the season. None of these are found in Monet's early garden paintings; nor did they find their way into the rough landscapes of Normandy, which provide the subject for his delicious first pictures.

The warmth and the scent of early summer – the time when the sun is at its highest – not yet laden with fruit and maturity, this is what Monet paints, painting the landscape ever more freely without losing sight of the structure of the picture. What Monet, the future Impressionist, creates here is an 'eternal summer of painting'.

*Colour plate p 20*

The first picture on this theme is the 'Flower Garden', probably painted around 1866. Topographical accuracy still goes hand in hand with painterly presentation, which is dominated by the strong contrast and interplay between light and shade. The rose bushes stand in front of dark foliage, enclosed by a second floral wreath of geraniums – this is how one has dared to interpret the brick-red flower dots – spreading in a gentle half-circle around their base, together with a corresponding half-circle that has to be imagined behind the painter; in between lies an area of lawn with the shadow of trees falling on it from the left. Green foliage occupies a third of the picture on the left; and at the upper edge are blue sunny skies with a bright house gable flashing through. Almost concealed behind all this pleasing growth, the beautiful country mansion can only be guessed at: the roof gable, the roof itself, the broad ledge, the

shutters of Tante Lécarde's estate at Sainte-Adresse, the only relative Monet remains temporarily attached to after breaking with his family.

This is an extremely charming picture. How many other painters have since caused a stir with a similar subject, the 'silent painters in the countryside' who are known only in their own town or region? Without any local reference points, this garden picture simply represents a 'summer's day' for the viewer; security and peace, memories of an hour of leisure or reading in a memorable garden. A pleasant coolness spreads from the left, while the sun has encouraged every single rose into full bloom.

In all his pictures, Monet pursues the eloquence of light with ever more refinement, a style of painting that characterises his work. The subject – whether accidentally or deliberately – is never just touched on; it is the 'only real' and valid detail, *pars pro toto*, of a small world in the beauty of summer. Here, unconsciously, Monet becomes an opponent of Degas, who is preoccupied with the young art of photography capturing the world in a new way, and makes use of its differing 'view', the detail, for his compositions.

The picture of Monet's aunt's garden is still marked by the civilised behaviour of a young man who is allowed to sit here so he can paint and carry away on his canvas the small paradise of this charming lady. Civilly, he thanks her by reproducing the most beautiful corner in the most beautiful light.

An indication of Monet's future work is contained in the 'Lilacs', painted twice soon afterwards, in 1872, with ladies resting in their shade. At the time it was usual to sit in the grass – as also painted by Manet – and wives or mistresses were used as models, removed into faint obscurity. The sunny and the sunless version ('Lilas au Soleil' and 'Lilas, Temps Gris') are kept in the Pushkin Museum in Moscow, and in Paris, in the Musée d'Orsay; they are certainly no accidental paintings, although in a smaller format (50 x 65,7 cm/ 19 5/8 x 25 7/8 in). Here, impossible to overlook, is an advance notice of the 'serial subject' painted in ever-changing light. The rushed detail of the 'lilac scene' suggests it is a study for a larger composition, which would be completed in the studio. The flowering lilac is the subject, and there is little room for picture narration, but the impenetrability of the shaded area heightens the glory of the flowering trees, which arch overhead like a vaulted roof.

*Colour plate p 25*

It was different with 'The Luncheon'. Really, considering what was being shown, it should have been called 'The Luncheon Table', or 'After Lunch'; for the ladies – visible through the foliage – are already strolling at some distance in the garden, while a child, sitting on the ground and deeply immersed in his play, creates the links within the scene; just as the parasol and the embroidered bag lying on the bench indicate a previous scene.

*Colour plate p 28/29*

Cups are recognisable in the lovingly painted table still life: a jug, glasses with the remains of some red wine, as well as a fruit bowl (*déjeuner* has several phases). Closest to the viewer Monet has painted a wicker serving table as if he had to make his contribution to the arrangement of the ladies' outdoor breakfast. In the upper, basket part of the table on wheels, fruits and white bread are liberated in a still life. All kinds of stories could be told about this morning idyll if it were not for the light and shade, the sunny and darkened blossom that begin to assert themselves over and above the narrative. It is understandable that audiences liked this picture when it was shown at the International Exhibition in Paris in 1876.

Monet had hit upon the people's taste. The black-ribboned straw hat, hanging in a tree; a 'lived in' corner of the garden near the house; the flower borders, the fuchsias in the container; the brightly dressed women, already slightly removed on their garden promenade, but still where a few steps would bring them back into the orphaned foreground; the child, silently lost in play, in the shadow: as in a picture puzzle, it all reflects a morning hour in summer; calmness, uninterrupted tranquillity contained within a small area, a security which at that time Monet still dreamed of.

Fine brushes still refine the blue ornamented coffee cups, as well as the silver of the coffee pot, the yellow basket weave of the serving table and the flower umbels of the hydrangeas and the flaming-red geraniums. The shadow of the tree, falling across the table laid in white is, further on the left, dissected into small islands that reach out into the sandy path. Even the rods in the back of the bench are given their due, rail for rail. The early mastery of Monet, who was as yet barely in his thirties, is demonstrated by this medley of pictures, which reaches its high point in the portrait of Camille in 1866[21].

The studio permitted Monet to divide shapes into smaller parts; it also allowed the effective use of bright in front of dark and dark above bright. The many details in this 'garden still life' registered by the eye, are in fact still individually described. Artistic competence makes them easy to recognise, stacked one behind the other in perspective. The painter holds back: the creator of compositions is still in control.

Turning from this still gently 'narrating' garden picture to the 'decorations' for Château Rottenbourg near Montgeron, not far south of Paris, it seems as though Monet only succeeded in liberating himself from the studio with these four sizeable canvases, intended as room decorations.

Ernst Hoschedé had commissioned them for the large salon of his country estate. In 1876, when Monet begins painting at Château Rottenbourg, Hoschedé is an immensely rich man, the owner of a castle, a collector, a patron

21 'Portrait of Camille', also known as 'La Dame à Robe Verte', 1866, oil on canvas, 228 x 149 cm (89 3/4 x 58 5/8 in), Kunsthalle Bremen

of the arts – including the young Impressionists – a friend of artists who enjoy coming as guests and even living here, most of all Monet who desperately needs such support. When Hoschedé's wealth collapses, when he has to give up Rottenbourg and his treasures and leave his family, when in a vain attempt he seeks to return to better days, the canvases go the same way as all ownerless pictures: first sold at compulsory auctions, they later change hands several times, until two of them end up in the Hermitage, the one of the white turkeys in Rottenbourg Park at the Jeu de Paume, and the most narrative – the hunter in the shoot – with art dealers.

One painting among these four panels, called 'Dahlias', with a lake flashing deep blue between the moving leaves of shrubs and perennials, is probably the purest development of a summer scene on the water. Monet, sure of his method, nevertheless allows nothing to dissolve in the picture 'decorations'. It must have been enchanting to relax in the salon at Montgeron, eye to eye with these landscapes shining out from a section of the walls that seems to open up into the outdoors.

'The Turkeys' in the park of the sprawling castle, whose façade is visible in the background, describes the feudal living space at Rottenbourg. Using an extremely painterly palette, Monet describes these busily pecking primeval animals in colours ranging from a cool, bluish white to bright feathers, flooded with light. He dares what is for him an unusual composition: the viewer seems to tumble into the picture, over the turkeys' heads.

*Colour plate p 36*

The Paris Exhibition of 1980 reunited the four pictures again after 100 years, which was most difficult for the fourth 'decoration', a slightly greying pond with vegetation around its edge: only the vivid reflections in the water betray Monet's skill.

These pictures show already how little Monet is inclined to hold on to any representation of the human form. After Camille's early death, the 'human being' disappears completely from his pictures, never to return or at least only in shadowy outlines and at most in the portraits of a few 'characters' such as Père Paul, the landlord and excellent chef in Pourville, on the coast where the painter resided in February 1882.

Our contemplation of 'garden pictures before Giverny' concludes with a famous painting, the 'Garden at Vétheuil', created in the summer of 1881 but mistakenly dated 1880 by Monet – a proud possession of the National Gallery of Art in Washington.

*Colour plate p 53*

This painting could be called a homage to sunflowers. It shows a garden path, steeply dropping off towards the viewer, on its steps a brightly lit woman and child, half in the shade of the tall stems of the mighty sunflowers; a second

child stands beside a small wheelbarrow at the bottom of the steps: they are Michel Monet and Jean-Pierre Hoschedé, the youngest members of a family unit which had come together because of need and death, two years after Camille had died in the modest house that is hinted at high above the garden.

The path, which leads down to the Seine and the painter, is festively lined by planted ornamental containers with blue decorations – a picture of summery cheerfulness. Light wisps of clouds chase across the deep-blue sky, which has been assigned only a small section here. But what Monet really intends with this sun-warmed picture is to detail only the shimmering heat above and between the 'wheels' of the sunflowers, with all his love, care and attention. At times, the dark brown kernels amidst the yellow wreaths of petals look at the viewer like dark eyes; at times, turned sideways, they can only be guessed at. They reign above a veritable wilderness of blue-green leaves. The density and impenetrability either side of the path increase as the ground rises. In the foreground, a corner of lawn indicates a garden space, where the Monets and the Hoschedés could escape from the cramped house. The boats also lie in the water here.

*Colour plate p 48*
*Colour plates p 44, 45*
After the pictures of drift ice on the neighbouring Seine, after the village of Vétheuil, which Monet has deprived of all its gloomy winter dullness with his palette, this garden shows him turning away from anonymity: his small green realm presents itself in all its flowering glory. The effect is created by just a few containers and the sunflowers, but they are like a promise of what is to come at Giverny.

# Motifs and working methods

Jean-Pierre Hoschedé, Monet's stepson, described[22] some 40 years ago – but probably still from his most vivid memories – what it must have actually meant for the painter to bring a subject to a satisfactory conclusion, after striding back and forth, scrutinising and focusing on it with narrowed eyes, to determine from which position it would be best to paint it. Unexpectedly, during a walk in the countryside or in the garden, he falls prey to a sort of tension, of the kind a hunter experiences when he sights game. Cigarettes, quickly lit and thrown away again, indicate to those around him that he has been struck by a subject with all the violence of an attack. Every other emotion dies; for he is already worrying whether he will be able to capture it, even before the easel has been erected and the canvas and painting materials have quickly been brought to him. Will the same light return again, the next day or the day after, since he can only remain at work for just under an hour now? The shifting light takes away with it the effect of the chosen moment, irretrievable for that day.

We probably have to take Monet's insistence on keeping to the exact time quite literally; it is a respect for the invaluable importance of the inspirational moment, to which he submits with such a degree of concentration that a profound exhaustion is often the consequence, and even depression when he believes he has not quite achieved the desired effect.

Always challenged anew, he measures his powers against the magic of light and the stillness of the air which is suddenly perturbed by a breeze, moving the leaves and upturning their differently coloured undersides, thus destroying the painter's vision. If, like Monet, one submits to the laws of the all-determining light, the search for suitable subjects – however ingenious – is but one worry. His mature works show how often he was successful in transforming a visual impression into the language of painting, outside in nature and on the water, but they do not reveal how often he failed. And when we consider his life's work, the relaxed cheerfulness of the garden pictures which have remained a feast for the eyes, they become – detached from their subject – the go-between for some kind of message from the artist,

[22] Jean-Pierre Hoschedé (1877–1961), *Claude Monet, ce mal connu – Intimité familiale d'un demisiècle à Giverny de 1883–1926,* Geneva 1960, p 107 ff

who is entirely preoccupied with deciding anew the colour in each picture and how to give it expression.

When his second wife, Alice, dies in 1911, the people around Monet believe that his energy will be depleted. Unflustered and determined, however, inspirational figures such as Clemenceau and Geffroy, who have a more profound knowledge of Monet's character than many, insist that this work – now essentially focusing on the water lily studies for the 'Nymphaeum' – is not yet finished, that he has not 'expressed' himself completely (*'parce qu'il n'avait pas fini de s'exprimer'*)[23].

[23] Jean-Pierre Hoschedé, *ibidem*, p 136

Monet submits to the demand, pulls himself together and completes the grand vision, with the garden as 'comforter', seemingly drinking in Monet's grief, more and more content with playing the role of a unique outdoor studio. The trees enclose this studio with their ever more magnificent height and density. The riot of colours penetrating the canvases in the latter years manifests itself like a great rebellion against Monet's diminishing eyesight.

*Colour plates pp 2/3, 140–142*

More on Monet's working methods: his work – created at the easel quickly and in profound silence – which transmits a subjective experience of light, does not consider the outside world; it produces monologues, Monet is 'speaking to himself in colours', and nothing else; there is no meaningful moment, no 'grand idea', which would have been out of keeping with Monet's conception of art and with the ideas of his period. The 'pallor of thought' has made way for blossoming colour: this is the entire philosophy of Impressionism. This is also the mystery of the lasting effect of the pictures of Giverny, which have often not even been painted up to the edge of the canvas. Even this sketchiness – part of the essence of Impressionist painting – is permitted as an 'ultimate work of art' since Monet. The sensation of the eye relieves thought, and confessions are replaced by ingenious visions. The 'indistinctness' of the picture, constructed from islands of colour and colourful shimmers, becomes a matter of principle because, all by itself, it comes together in the most beautiful distinctness when the viewer steps back from it.

Even if the ever-changing weather in Normandy, with its sudden 'violence', interrupted Monet's outdoor work many times, even in the garden, then we still owe the abundance of pictures to this 'act of God', to the 'battles' with nature that started ever afresh. Monet always rises to the challenge, especially since he is never content, least of all with himself. Adversities were also to be found within the man, who was probably always looking to regain happiness in his life. He did not appear as the calmly tolerant type of great artist, nor as one obsessed by a creative restlessness, but as the creative man of modern times who, for a long time – and often for too long a time – commissioned

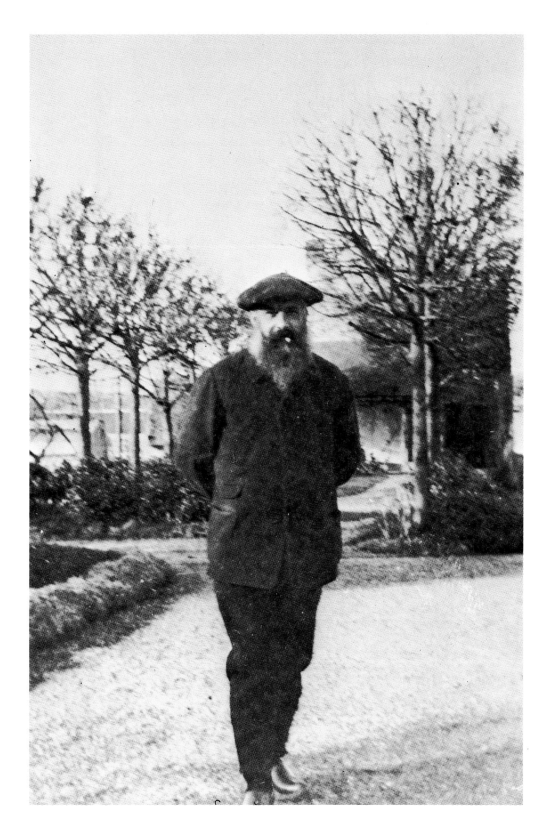

*Monet in his garden
in winter, ca 1895.
Collection Durand-Ruel, Paris*

himself, without encouragement from anyone until, after years of poverty and with a delay that could have caused bitterness, his vision and work were proved to be prophetic.

Monet's work from Giverny has experienced the same fate. Thirty years after his death, when the large studies for the 'Nymphaeum' were allowed out into the world, 'released' by his son Michel, they caused the great misunderstanding that has already been mentioned. Monet's subjects did not take shape in his head, instead they were quite Norman, rural and real: on the pond, which from time to time is fed with fresh water by the Ru, close to the meadows and pastures in which owls nest. This is the origin of what Monet makes real in his visions of the garden.

*Illus. p 120*

*Colour plates pp 68, 69, 71*

*Colour plates pp 64–66*

When we think of Monet's giant *oeuvre*, created in his garden and later in the third large studio, a wealth of pictures from several decades, it is regrettable that it is so widely dispersed. It had been Georges Clemenceau's fervent wish to keep the picture series of the haystacks – painted at all times of day, in summer and in winter and in which the lighting effects reached new heights – together as a cycle, just as the poplars, and to exhibit them together like this in the long term. Nevertheless, they went their different ways at their first showing in Paris, when assorted collectors bought them. What these paintings had prepared for – especially the straight stems of the poplars, at times cold blue, at times flaming yellow – became complete in the garden of Giverny: no longer is Monet interested in the manifold aspects of a picture subject such as the drift ice on the Seine in winter; instead, constancy is what fascinates him now as he makes himself the focal point of a scene where subjects surround him, waiting patiently. He no longer has to change his position but only the direction of his gaze, and often not even that. He has to prove himself anew at the water lily pond. Many times before, wading through the meadows, he had to overcome nature in its most summery dress. Now he is transfixed.

# The garden becomes painting

## Paths, trees, grasses – a blooming wilderness garden

The iris-fringed paths in the *Clos Normand* with their many clearly separated zones of coloration are a sumptuous introduction to painting in the garden. Monet is overwhelmed by the density of flowers. And he almost expects too much of himself on the canvases, which in only a few square centimetres already give a clear indication of the imagined colours of the whole painting. Their sparkle is reminiscent of the individual windows in nearby Chartres cathedral. The representation of such magnificence, this true glory of richly orchestrated colour, reaches its high point with the subject of the 'garden path', another cycle of paintings, created around the turn of the century. By then, Monet has had his first visions of the Japanese bridge – at this point still without the rampant overhanging wisteria, with its pale violet flower heads, which was eventually to conceal the bridge's delicately curved shape. These garden path pictures are followed by the first series of paintings of the water lily islands on the pond.

*Colour plates pp 80, 84/85*

*Colour plate p 123*

*Colour plate pp 133–136*

Monet's only rule in life now becomes even more apparent: to work until he reaches his physical limits. We are reminded of Emile Zola, with whom he broke after the novel *L'Oeuvre* because – as Monet saw it – it contained biographical features that were too clearly recognisable as relating to Monet. It was Monet, however, who, when addressing young people in the 1890s, said: '…work. Remember that it is the only rule in the world. Life has no other purpose, there is no other reason to exist, we are all here only in order to do our bit of work and then to disappear.'[24]

[24] Quoted after: Egon Friedell, *ibidem*, p 401

It sufficed for Monet, up to his last day. Any thoughts of salvation were far from the mind of the unemotional child of Normandy; work, without ever being content, was to him an effective protection from an exuberance of words, which people thought they could use to get closer to him, an ageing man. For him, words held the danger of 'numbing'; for the bombastic hymns of his contemporaries, as they passionately described his work, went way beyond its natural, lonely greatness and made this late and mature work of his suspect for decades to come. Only the initially biting comments from the

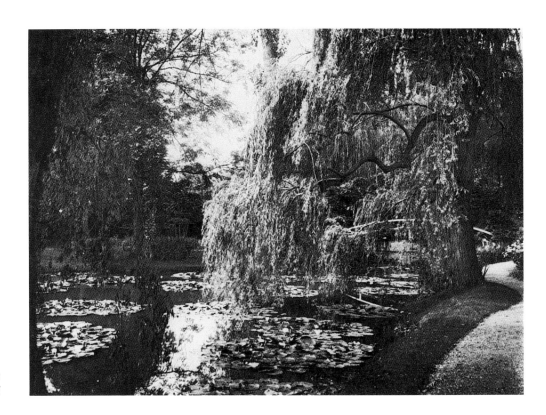

*The weeping willow next to the water lily pond*

25 Jacques-Emile Blanche (1861–1942), French painter and art critic, in: *La Revue de Paris*, 1 February 1927, p 562

press sought to keep everything 'earthbound'. Monet actually needed them, to have a reason to be enraged, even 'unchristian'. 'Unchristian', away from the consecrated field of graves in the village cemetery of Giverny, on the sloping path, is also where the tomb of the Monets and Hoschedés has its place, where only a simple name plate identifies the grave of Claude Monet, one among many. The painter Jacques-Emile Blanche[25], when thinking of Monet's funeral with a slight shudder, called it the 'eerie end of the unbelieving loner, without bells, without prayers, without incense' *('lugubre fin de solitaire incroyant, sans cloches, ni prières, ni encens…')*. But this sentimentalised picture of what the funeral of a famous man should have entailed is only what curious people from village and town expected. Monet's reflections were concerned with 'this Life', the paradise of his gardens.

Being intimate with tree and shrub, with every perennial, every rose bush, even with the ornamental grasses on the banks of the stream and the pond; day by day, carefully observing the numerous flowers in the sun as it suddenly emerges from behind the cloud cover increasingly enables Monet to capture the unique qualities of individual plants. In the garden pictures which conclude his life's work, the pure landscape motifs – the pond with its path romantically

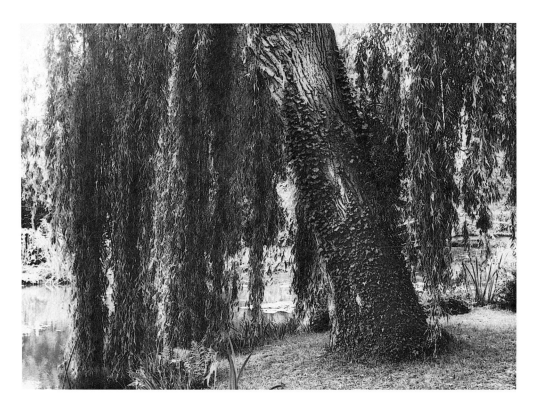

*The weeping willow today*

snaking alongside its banks and the rose arches in the *Clos Normand* – become rare; rarely, too, does he elevate the marginal areas with the high trees around the pond to a subject for his paintings – as he did somewhat fantastically in the picture of Grenoble – suggesting the wilderness of a nature reserve. The close-up view alone accords with his ideas; it allows him to realise his vision: to see nature as colour and to spontaneously entrust this to the canvas. As we have indicated, he does this by no longer mixing colours on his palette: instead he applies pure colours. This was the only way in which he could achieve the feeling of 'the moment' that he always tried to conjure up: the result of endless and exhausting effort.

*Colour plate p 118*

Monet's artist friends must soon have been gripped by his painted delight in expressing the flower picture of his gardens with ever-faster brush strokes. Only a few of the studies are still kept by the Musée Marmottan in Paris, to whom his son Michel gave the estate. Most of the paintings have moved on to other collections and museums, and with their ordered magnificence they appeal to ever new generations of viewers, even though these would not know of the famous, simplifying statement by Cézanne: 'The sky is blue, isn't it; you see, and Monet discovered this.' In reality he meant the wealth of colour

revealed in his paintings. Even the shadows become colour; black and grey have disappeared. This is what is so overwhelming in the pictures Monet paints at Giverny; that everything which belongs to the world of darkness has been deleted from them.

The Impressionist Monet, the painter of light, as he has been described, passes on through his personal vision the fully open blossoming of the gardens; not the budding or the withering; not the not-yet nor the no-longer of colour. Just as he 'lays reins' on nature by not leaving it in its primeval wilderness and by wishing the surface of the water lily pond to be free of impurities at all times, so he also shows patience in bearing the long months of a Norman winter, the time without flowers, until the beginnings of a new spring, when he can entrust newly experienced colour to his canvases on the easel. The later panels, the magnificently sized studies created for the 'Nymphaeum' of the Paris Orangerie, show what a treasure of experiences he gained this way *en plein air*.

Of course, the 'task master' desires this purity of blossoming only in the areas close to the ground and the water; the trees – his friends – which delimit his garden territory from the meadow landscape and which – like wind harps – protect his rose arches, grow freely into the sky. And all the inhabitants of *Le Pressoir* are deeply dismayed when a storm tears down one of the two weeping willows on the water's edge.

## Immersion in details

Nevertheless, Monet does not become a botanist as he paints, however much he knows the shape and peculiarities of flowers and grasses 'by heart'. Whether his gaze falls onto an individual flowering branch, a group of yellow lilies by the water or onto delicate dark blue iris petals in front of a cloudy blue – not described in greater detail – or pink near the pond; or onto the pale violet heads of agapanthus amidst waves of bluish green: these are a testimony to an unusually powerful imagination of colour, not the study of plants by a hobby gardener.

Waves of motion go through the sword-like leaves of the lilies, through the yellow flaming grass – in clumps and at times like the greenish golden precipitation of rain – ranging across a dark ultramarine, occasionally ochre-yellow, brownish violet or emerald green; never an area, but instead innumerable brush strokes, applied on top of one other: water. Some flowers

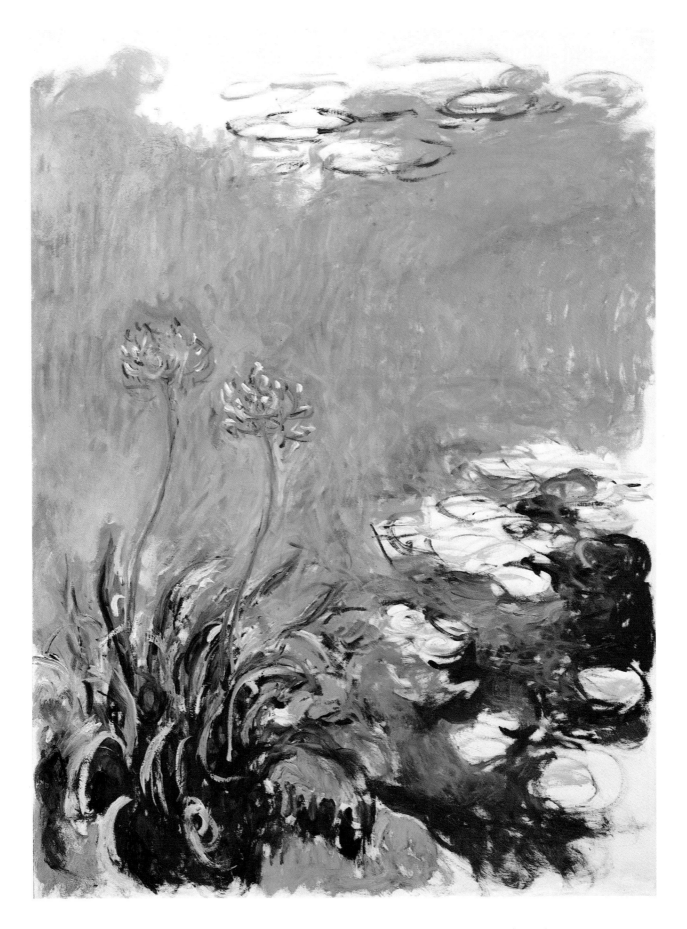

*Blue Tuberoses. Ca 1918–25*

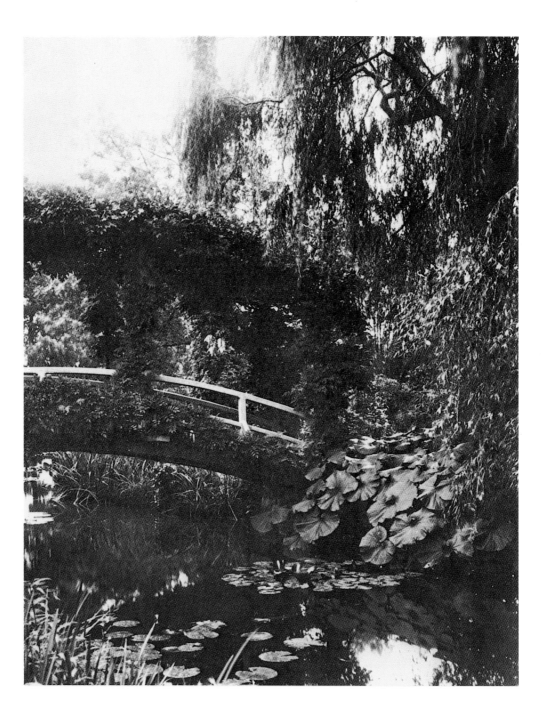

*The Japanese bridge,*
*overgrown with wisteria;*
*on the water surface the large,*
*round leaves of petasites.*
*Collection Truffaut, Paris*

can only be guessed at, their colourful torches in front of a contrasting background – supported by the flashing white of the under-paint when the study demands brightness here – and between the deep darkness of the foliage.

*Colour plate p 115*     And by making the delicately feathered 'balls' of the agapanthus – the 'blue flower of Africa' – into the densest points of his composition, he virtually

turns the colour tones upside down: bright in front of dark or bright on top of dark, keeping to a range of white, violet and a deeply satiated ultramarine, with a manifold green – ranging from transparent warmth to the cold green of oceans – applied in dots. And no colour 'dominates'; all gain their strength from the contrapuntal behaviour of their neighbours.

Such studies, to which the now nearly 80-year-old artist still devotes himself, almost transport Monet's art into the realms of meditation. Intellectually remote from his former comrades-in-arms, who pursue different artistic routes, he restricts the persuasiveness of his subject so much that it virtually gives up its botanical shape altogether and merges into a flood of colour harmonies. When he leans over the water, on the banks of the stream and the water lily pond, visions appear to him which eventually become mystical experiences of nature. It is now no longer of any importance whether he completes such canvases outside in nature or in the large, light-flooded studio. They resemble chords, and although inspired by their impression in nature, no longer seek to recreate it.

*Illus. p 120*

The garden is unimportant and forgotten, and the absent sky transmits light for dreams of colour from which 'vegetation' has withdrawn, apart from a few panicles and leaf tendrils underlain by blue shadows. Fragments of violet irises drift on top of a denser blue; above, soft orange-coloured veils are woven into a 'sound'. The poetic power of painting finally triumphs over nature, while granting the fleeting moment an afterlife, a permanent beauty. The picture area absorbs artistic experience, an adventure, which only much later steps out from the cocoon of a summer's day at Giverny into the world: this is not the document of a painterly idea, not a 'garden piece', nor the successful attempt at a finely drawn detail, but the transformation into a higher form of existence in art.

*Colour plates pp 140, 141*

While immersing himself in the rule of light over the garden with all its nooks and crannies and islands of flowers, Monet goes through the hard labour of conceiving, as he had done already in the landscape, and he does so with a sort of menacing, silent obsession. Moroseness recedes again, just as it attacks him if a vision does not translate into reality.

We do not know how many drafts of pictures he consigned to the fire, or whether this is just a legend. That he has reached the limits of what he can demand of his skills can be seen most clearly in these studies, from which he has banned everything that might please the viewer: recognisability, comprehension, in short anything that can be grasped. Visitors from the Far East will have been most enthusiastic about such studies, recognising in the branches and flower umbels of the wisteria 'dripping' out of the sky what

*Colour plate p 2/3*

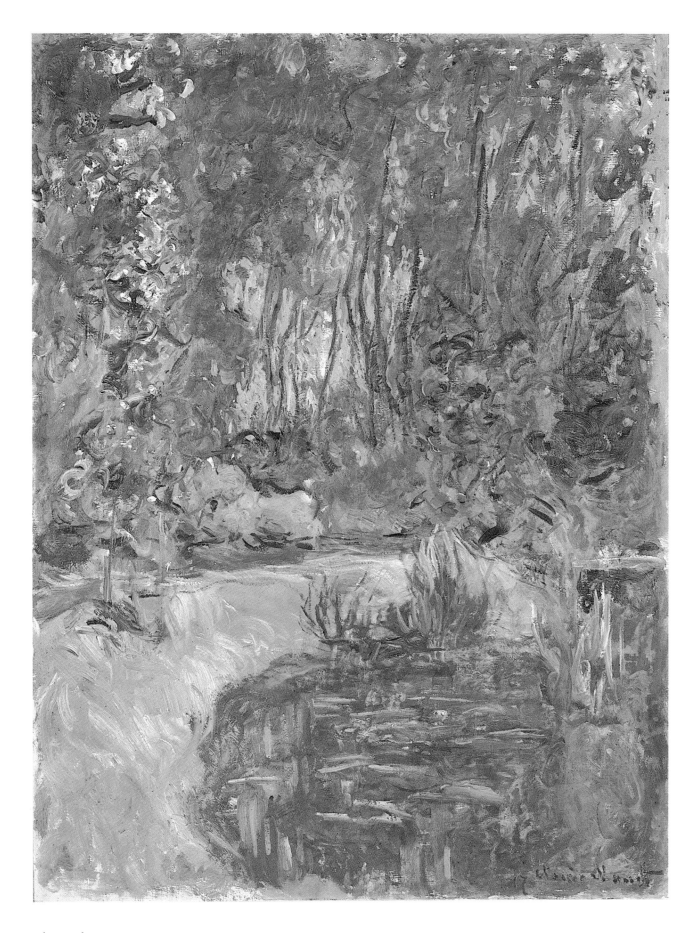

*The Garden at Giverny. 1917*

they were used to seeing of old, in the works of their own master, Hokusai. In the master's pictures the decorative element is elevated to the highest rank and importance. It is in these innovations that it is easiest to comprehend Monet's idea of continuing such floating chains of motifs formed in the lightest way: ideal picture backgrounds, dissolved perspective, fleeting pastel brush strokes, weightlessness.

Indeed, he turned his attention to such 'colour hangings' for a long time, in an unimaginable creative process, using ever-larger canvases. Plant and flower, growth and its location in the garden all merged in his paintings. The brushes create their own 'ways of writing', at times in shorthand, at times in great detail. It

*Wisteria tree from Monet's time*

is understandable then, that since Kandinsky, 'art without objects' believed it had found something of a forerunner in Monet, while in fact he was only abandoning himself to the extension of his colour imagination. The pale wisteria, spun lightly through the picture plane against the blue of the sky and returning in a mirror-image on the water, is seen in more and ever more daring versions; these are, of course, also directly connected with the most important feature of the gardens at Giverny: the Japanese bridge.

## *Model for the artificial form – the Japanese bridge*

From his days at Argenteuil, after returning from London and the Netherlands in 1871, Monet begins to collect Japanese coloured woodcuts, which first appear in Paris around this time. Artists from Monet to Vincent van Gogh, a latecomer to Japonism, are gripped by a wave of delight, and many a painter's style is influenced by this previously unknown world of pictures whose dissolution of the depth of field revolutionises their way of seeing.

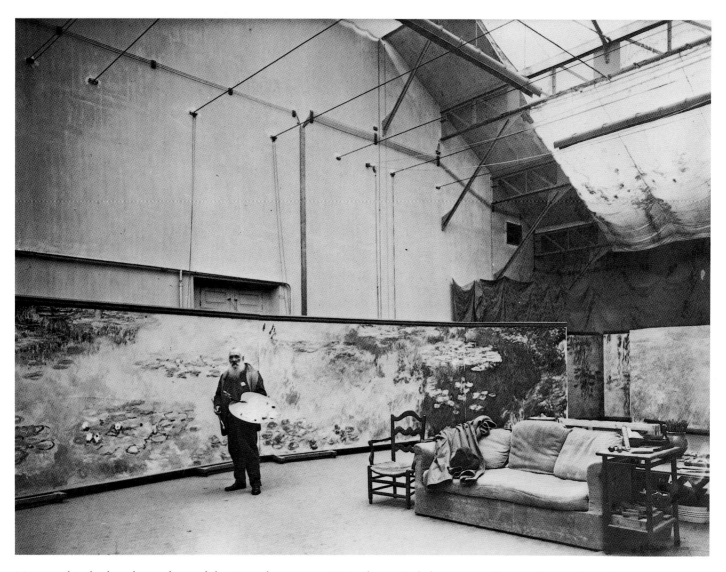

*Monet in his third studio, in front of the 'Nymphaeum', ca 1920. Photo: Michel Monet. Collection Durand-Ruel. Paris*

*Illus. p 23*

Thus, the living rooms of the house at Giverny are now decorated exclusively and as a matter of course with these Japanese coloured woodcuts, framed and displayed just as they can be seen today. The inspiration for the Japanese bridge, which was to span the western outlet of the pond as an exact continuation of the main path from the *Clos Normand*, models itself directly on such representations of this much admired Far-Eastern world, so different from our own, Western European world.

The structure, reaching across the water in a gentle curve, looks strange enough in the earliest preserved photographs. Powerful though light, and certainly curious in this landscape of poplars and willows coppiced in the French style, their naked stems drearily pointing skywards like fingers, the bridge swings across to the water lilies and wild irises, to which Monet would soon add exotic lilies, all sorts of water plants, bamboos and grasses, when in 1892 he makes his vision of the water garden become a reality. It is a motif with a high degree of painterly charm, as will become apparent; it also gave views onto the water from a slightly raised position. Again and again, guests and friends as well as newly acquired relations – when sons and daughters have married – parade on the curve of the bridge in a small roundelay of understandable vanity. But this happens at a time when the 'Miracle of Giverny' has already outranked the wisteria, and the woodwork of its curves is concealed behind bizarre branch formations.

*Illus. pp 88, 97*

Before 1910, Monet paints the bridge, this veritable masterpiece of carpentry, many times from the water, as a completely ethereal, tripartite curved shape floating freely from picture edge to picture edge, at most anchored by the tall ornamental grasses on one of the banks. The painter's colours covering it 'discolour' from a sonorous, drowning blue to a light yellow or transparent green, the sharp 'Monet green', deliberately detached from nature; for it partakes in an artistic enchantment that casts a spell on the water, the water lily islands, the grasses on the banks, the branches of the weeping willows and the dense foliage behind, which complete the stage set.

*Colour plate p 123*

At times the bridge is cloaked in greenish veils like the vision of a balustrade, transported and inaccessible; at times it is strongly marked by light and shade in front of dark masses of foliage, gliding across floating fields of flowers which respond to its graceful curves with a cool blue-violet. At times its curve rises and falls with the ever-changing sparkling of light on the water and on the chaos of leaves above; at times it swings across the picture stage like a nocturnal dream bridge in a deep blue. Only a few individual sections flash in the bloom-covered water and in the branches of the weeping willows – which resemble the golden rain of fountains – and in the marginal grasses; while the pink-coloured chalices of water lilies rest coolly, like ornaments on their leaf plates: unreality. Water, darkened to a reddish brown, dawns from the depths, only once disrupted in short intervals by the reflected colour strands of the weeping willows, *saules pleureurs* as they are known there onomatopoeically.

Monet, wishing to exhaust the motif's moods, burdens himself with an enormous amount of observation. It seems as if the Japanese bridge with its

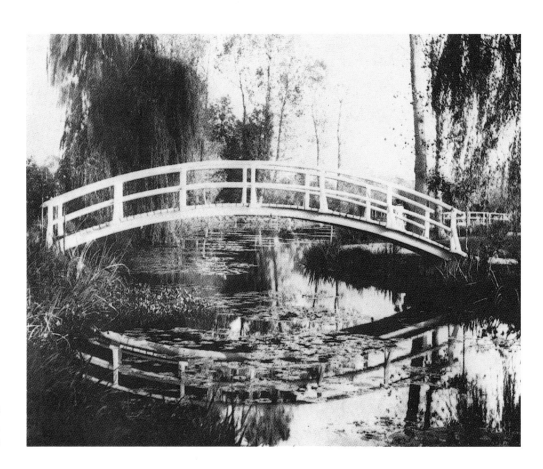

*The Japanese bridge across the water lily pond, 1902. Collection Piguet, Paris*

firm railings, its pillars and their duplication in perspective when seen diagonally from the bank, still gives him the necessary support. The top and bottom, the emerging growth above the water, the 'idyll' on the bank, the tangled grasses too, frame and encircle the water surface where the real events in his art, his extreme 'inventions', take place. Only when his eyesight begins to fail him one late day does he abandon himself – after a successful cataract operation – to a veritable intoxication of colour, where the bridge – now completely overgrown – is only sketched in outline, leading through a veritable glow of fiery colour embers.

*Colour plate p 48*      Just like the drift ice near Vétheuil, he is fascinated – now in an 'eternal' summer – by the flower-covered water surface; *la nappe d'eau* (the surface of the water) with its vertical colour hatches only emerges in the bridge paintings to help the eye make out individual islands of leaves and flowers, which Monet elevates to his jewels. If we could see all the bridge paintings together again we would be astonished by the almost unimaginable effort made by the

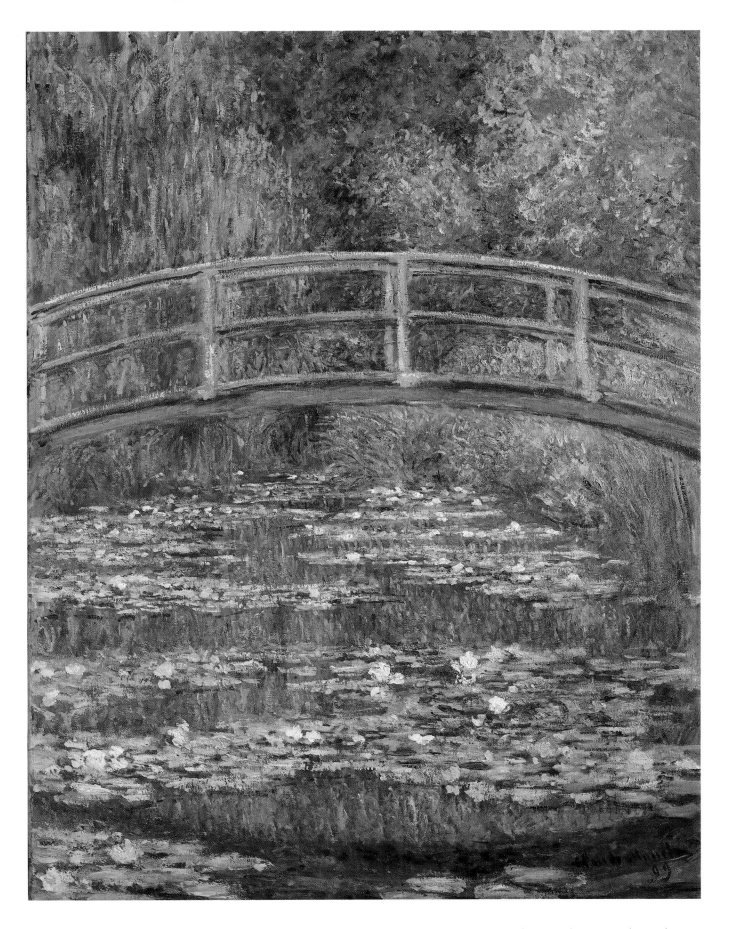

*Bridge over the Water Lily Pond. 1899*

brush-hand of this single painter. In some of the versions, which have all been painted from the same position, an energetically sweeping line asserts itself near the bottom edge of the picture to counter the bridge's arch, a corresponding shadow which gives the assurance that the banks are part of the water garden's reality.

Here Monet's art loses its connections with contemporary painting. Bonnard and Roussel[26] will move closer to Monet's discoveries than Pissarro in his later years, who was occupied by Seurat's pointillism for some time. Monet is now the individualist, the artist who completes the Impressionist way of seeing, just as he was its 'inventor'.

[26] Ker Xavier Roussel (1867–1944), French painter

Once again, it is not the garden at Giverny that brought about this conclusion, but the garden the artist created – probably unique in modern art – which provided the medium that was to allow his art to find its final word. A terrain patiently lay in wait for him here: a stroke of luck, considerably helped along by his increasing wealth. The wretched painting attempts by those around him – apart from those by the faithful and talented Blanche Hoschedé – show that it only responded to his genius.

Illus. p 122

As an existing artistic shape, the Japanese bridge only served to alienate in the barrenness of the first hour. The painter's 'eccentricity' is nothing but an artistic and equally practical form of foresight: if he had had a straight bridge erected over the water, it would have needed a central support pillar to cross from one side of the water to the other, like farmers had done since the days of Rembrandt (compare, for example, his famous etching 'The Bridge near Estate Six' of 1645). By choosing the Japanese style of curving bridge Monet created open views through to the larger water surface beyond the bridge – because judging by the direction of the incidence of light and the position of the weeping willow he must have painted the bridge from the narrow, western part. At the same time, he created the only imaginable lightweight construction that looked interesting next to the *nymphéas*, which would become the truly dominating feature of the region, although they cannot easily be considered native Norman pond plants, nor can they be found anywhere near Giverny.

## Rose arches

Monet's thoughts are continuously circling around water, to which the pond next to the meadow stream of the Ru introduces calmness. They help him discover ever new, initially still 'conventional', motifs as he meditates on his

resting bench under the rose arches, at the southern mooring for the flat-bottomed boat. He had to fight his family, obsessed by 'nature' and the natural, to erect the overgrown metallic arches for the simple climbing roses, the second artificial form here apart from the bridge. In the beginning, they too splayed out like rigid skeletons across the main path in the upper garden and later next to the pond, not promising much poetry. But soon they are covered by the rapid and many-shooted growth of the climbing roses, which shape them into true Sleeping-Beauty arbours.

In a painting from 1913, Monet captured the rose arches and their reflections in front of a light, hazy sky, seen from across the water and towards the meadows of the drained swamp – one of the rare subjects to contain a certain fairy-tale sweetness, something that the otherwise strict colour studies would hardly have permitted. But the way the delicate triumphal arches with their roses, slightly shifted in perspective into the depths of the landscape, rise into the mild air amidst nothing but flowers on the bank, trees and shrubs, and the way their lighter and brighter mirror-image appears in the water, unperturbed by water lily islands – this is Monet's 'rococo'. With its melodiousness and beauty, it harks back to Watteau, but without the gallant figures of a bygone era, which the painter did not even remember or think of in passing; he thus preserves from any anachronisms this pure painting of an artful nature, a tamed and yet still natural growth and blossoming.

*Colour plate p 126*

To pay homage to such a garden in painting would have seduced lesser spirits. Monet made the rose arch, without further subject reference or key, the sole theme of his picture, not intending to convey the melancholy of a summer day. Everything is blossoming colour, and the swimming leaves and flowers of the water lilies stay near the edge of the picture, distant and individually woven into the reflections of the arches. Even Debussy[27] would have found it difficult to match this with his composition.

[27]Claude Debussy (1862 St Germain-en-Laye – 1918 Paris), French composer; main representative of musical Impressionism

There is a beautiful photograph of the elderly Monet, which shows him in front of this painting, now 73 years old, with a white beard that had never been trimmed, having returned to the easel for a second time grieving for his wife and companion. It is possible that for a picture like the 'The Rose Arches', which is still of the usual Monet format (ca 80 x 90 cm/31 ½ x 35 ½ in) and in which every last corner has been designed, final brush strokes in the studio had seemed appropriate; for the rather solemn photograph shows the painter wearing his 'Sunday outfit' in the studio. The resting place, which he recreates in his painting and which he sought out until his final days – long fitted out with the famous blue spectacles – has today closed again as a round curve, thanks to the constancy of nature.

*Illus. p 130*

*Illus. p 151*

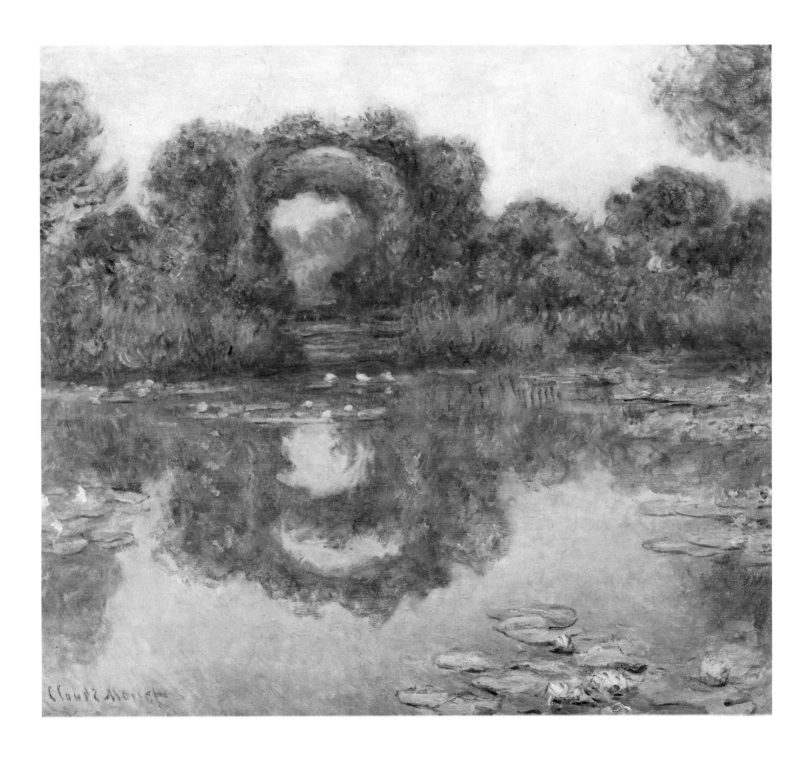

*The Rose Arches. Ca 1912*

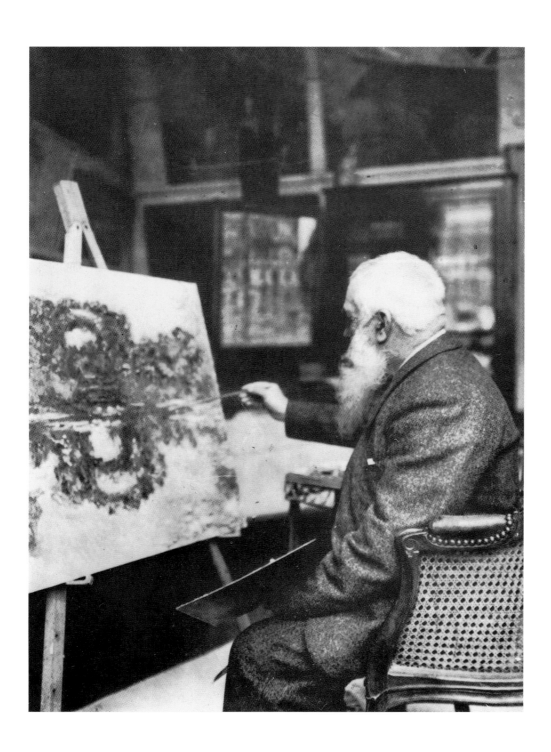

*Monet in his studio, refining his painting of 'The Rose Arches',*
*1920, Collection de la Réunion des Musées Nationaux, Paris*

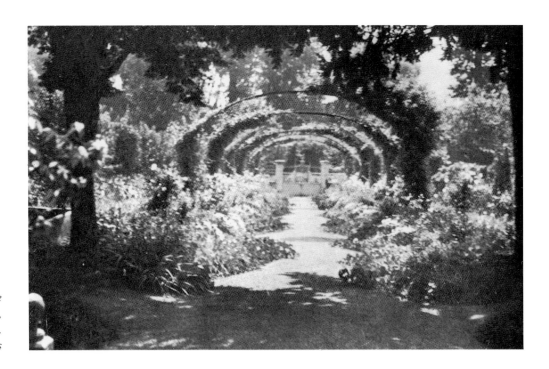

*The main path from the
house into the garden,
covered by climbing rose arches.
Collection Toulgouat, Paris*

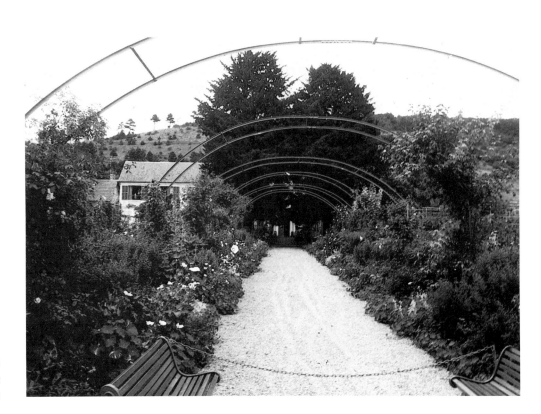

*The main path with
the arches for the climbing roses
after reconstruction*

## Water lily pictures

The winter of 1910 brings home to Monet how fragile an 'open-air studio' he had created for himself with the water lily pond. The high waters of the Epte wash away the water plants, devastate paths and embankments and even flood the tracks of the little railway line so that the train no longer huffs and puffs past the garden fence once a day, on its way from Vernon to Gisors and back. It is a long time before the water lily islands extend their leaves over the still waters in renewed splendour to continue their flowering, which around the turn of the century inspired Monet to what are probably the most beautiful pictures of the pond.

*Illus. p 130*

These 'shaped dreams' complete his work. On moderately large, almost square canvases, which he has propped up on the easel close to the bank, he devotes himself – often in the shadow of a large painter's umbrella – to this subject, which now only needs the pure surface and the dull green leaf plates, stretched as diagonal ovals in perspective, and occasionally a glimpse of the opposite edge of the pond nearby. We can see the blurred reflections of trees, clouds and blue sky, pale or in a satiated colour, or in the interplay of numerous alternating, finely graduated colour tones. They make it easy for the viewer's imagination to 'know' about the landscape above the water without actually seeing it, since it extends beyond the upper edge of the picture. With the utmost sensitivity and an incomparable effort, which Monet complains about in his letters[28], this watery mirror is explored right up to the most delicate drifts of a colourful interplay of light and shade, and always for just this one hour of similar and comparable brightness. The picture edges often crop into the flower islands in the foreground and thus complete the illusion of an unlimited area of water.

*Colour plates pp 133–136*

[28] Monet in a letter to Geffroy, quoted in: *Hommage à Monet, ibidem*, p 329

The perfectly pure surface, interrupted only by the field of water lilies, is the endlessly varied theme, again in a sort of 'series', always with a wealth of reflections which – in this series – do not allow us to see the bottom of the pond from which the leaf and flower stems rise. It is not botanical knowledge that is being passed on here, it is the long story of a flower dream on the water. White, yellow and pink-coloured *nénuphars* or *nymphéas*, water lilies with a full, round calyx above and between the flatly spread-out leaves, absorbing the light, are placed – dotted, fluffy and spontaneous, with small shadows and flashing lights – above the darker reflections of trees and moving sky. And they are actually only 'water lilies' because we know they must be, not because it is apparent from their painterly representation; for Monet uses only a few

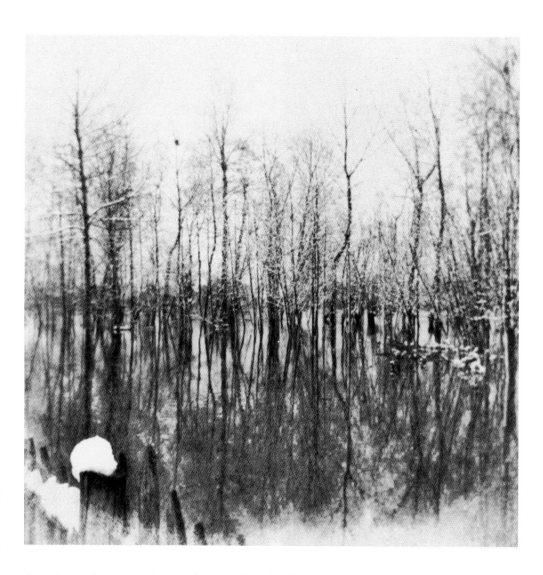

*Winter 1910: the water lily pond and parts of the garden were flooded; many plants died. Collection Toulgouat, Paris*

*Colour plates pp 138, 139*

brush strokes, mostly in white and pink, for these first pictures. According to Impressionist theory, the detailed description of the flowers would have destroyed their overall appearance, would have left the eye lingering over an irrelevant detail; while the radiant abundance of light and darkness, the reflection of a passing cloud, a piece of blue sky, are meant to be the only determining factors in this picture area without borders or limits, mostly also without horizon; all this in the enchanting contrast between areas that absorb the light and those that throw it back.

Their subtle structure as well as their pictorial unity still clearly differentiate the earliest water lily pictures from the later ones, the large, room-sized 'decorations' created in the studio, which complete the cycle of the 'Nymphaeum' of dreams, in the Paris Orangerie, as nineteen panoramic

pictures, which have the artistic experience of this quiet world as their ongoing and continuous subject.

The first painted pictures in a rich series, also called paysages d'eau (water landscapes), soon found their way into mostly American collections and museums. In 1900, 26 water lily paintings were exhibited in Paris by Durand-Ruel, under the title suggested by Monet himself, 'Les Nymphéas, Séries de Paysages d'Eau' ('Water Lilies, A Series of Water Landscapes'); a further 48 were exhibited in the same place in 1909.

Both exhibitions were very successful and increased international awareness of Monet. The full wealth of studies that were painted or completed in the studio only became known to the astonished art world in 1956, with two exhibitions in Paris and New York.

The weeping willows, bamboos and lilies, which Monet had planted on the banks of the pond, are lost in the first water lily pictures as mysteriously schematic, narrow fringes, or at most we are only reminded of them in an 'upside down' world. The foliage, trailing in thin branches onto the water in some of the picture variations, allows us to guess that Monet, without thinking of a great plan like the 'Nymphaeum', is dreaming of decorations, picture fragments, which will become a unity that magically captures the viewer only once strung together in a grand cycle of paintings. Morning and evening, the hours of light under a sky that is not 'eternally blue' but capable of all sorts of transformations: this becomes the entire content of his art, which has chosen the water lilies, opening and closing again with their many-petalled flowers, as its protagonist.

*Colour plate p 138*

## Pure reflection

It is well known how great the effect of these 'painted meditations' was on his contemporaries – poets, critics, painters, anyone else with heightened sensibilities. The inspirational force of the perfectly beautiful, of a paradise amidst wilderness, or to put it differently: of pure reflection – no longer of reality, but of the painterly visions of a great artist – still lasts today.

Monet's Giverny has remained unrivalled, without equal before or since. In the European tradition, artists were at first allowed to paint imagined 'little paradise gardens', then they described parks and gardens, overwhelmed by their beauty, 'portraying' them, and also expanding these copies of their

surroundings into idealised pictures of their dreams: a homage to enchanting beauty they encountered, conceived and cared for by others or left to run wild. They are guests, in both other people's and their own green terrain, whether this is a town wall with a few flowers in a window-box or in a garden on a feudal estate; whether under a tender-leaved arbour or in a shady garden hut of great age at rest; or in memory of a delimited piece of flowering, which they managed to tear out of oblivion.

*Illus. p 33*
*Illus. p 151*
At first Monet, in his disobedient Norman wooden clogs, trudged through a garden with trees on whose mouldy branches small cider apples were rotting away; later he sat near the water, well-dressed and peaceful, wearing his broad-rimmed straw hat, resting from his dual work: the garden and painting.

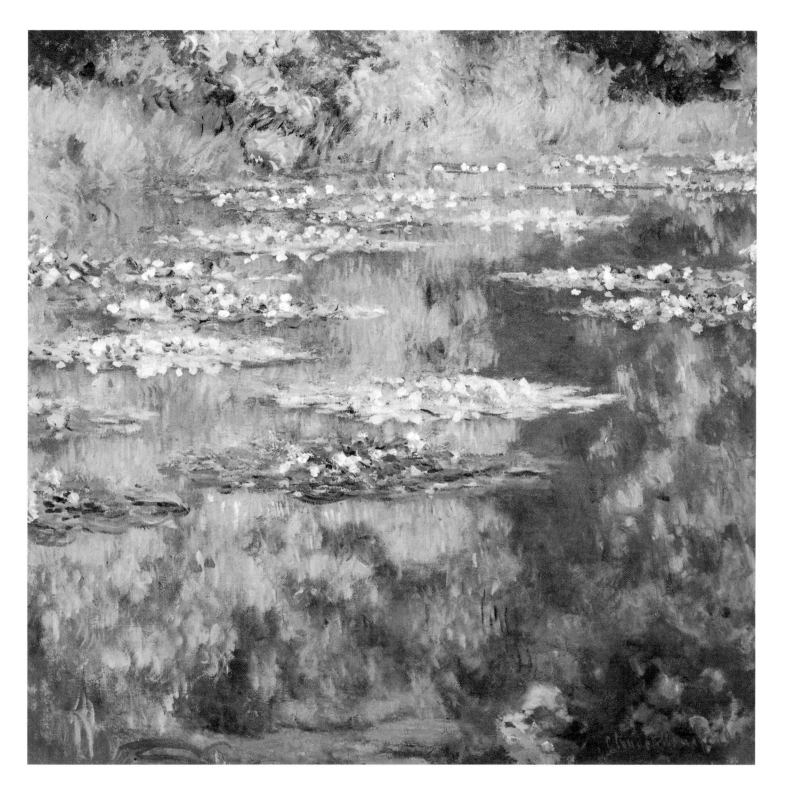

*Water Lily Pond. 1904*

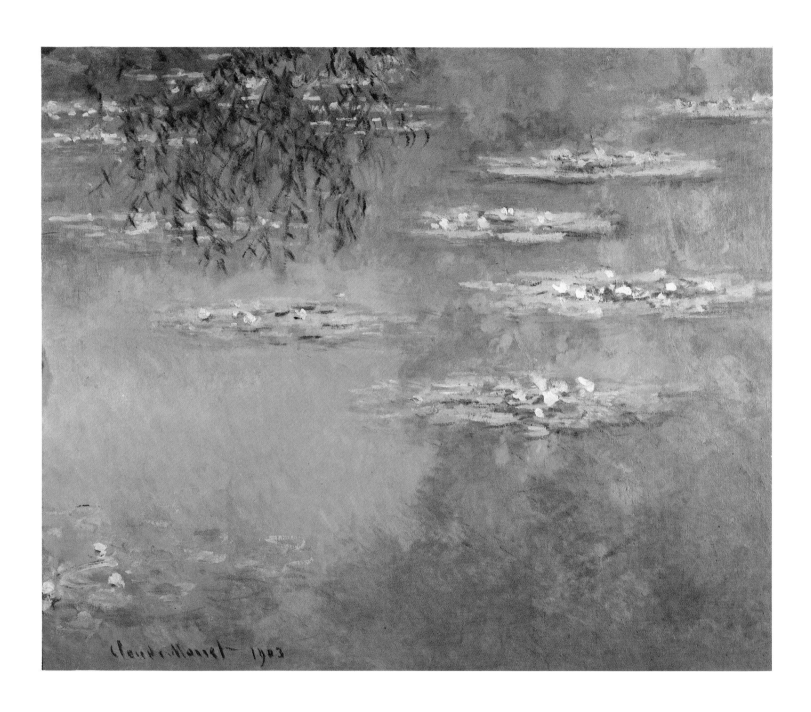

*Water Lilies. 1903*

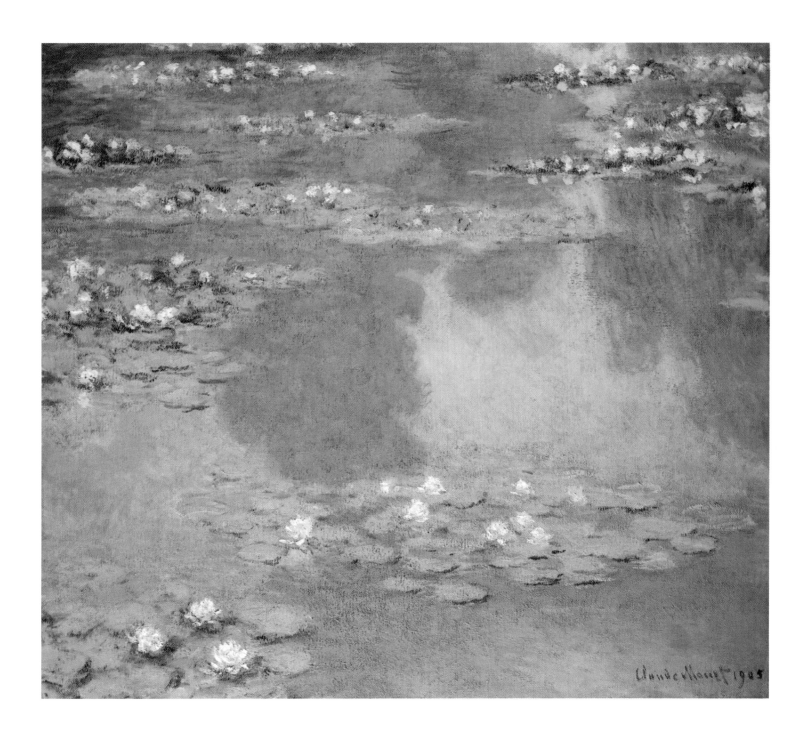

*Water Lilies. Water Landscape. 1905*

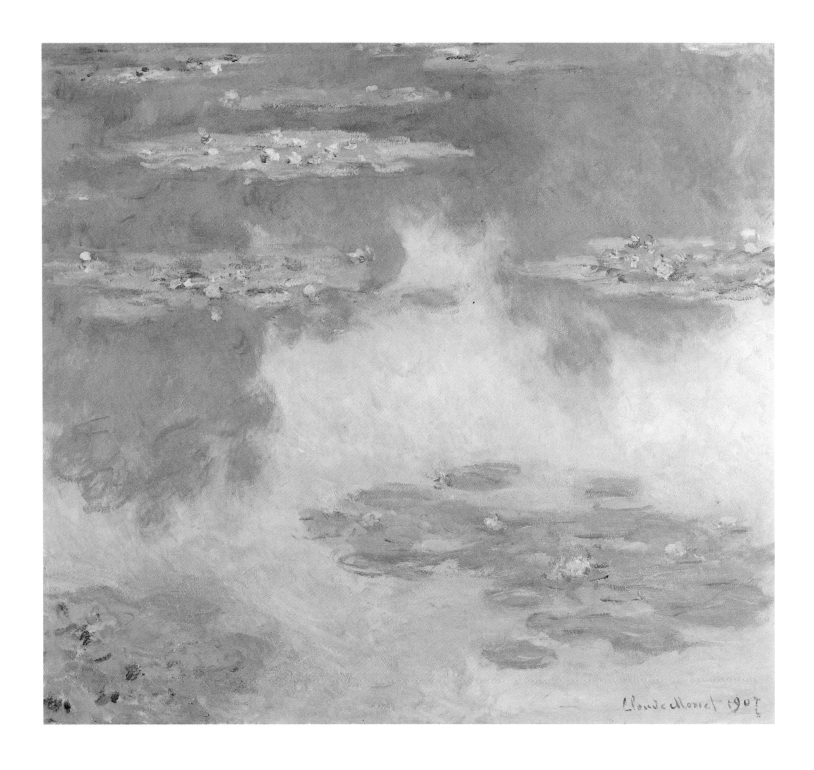

*Water Lilies. 1907*

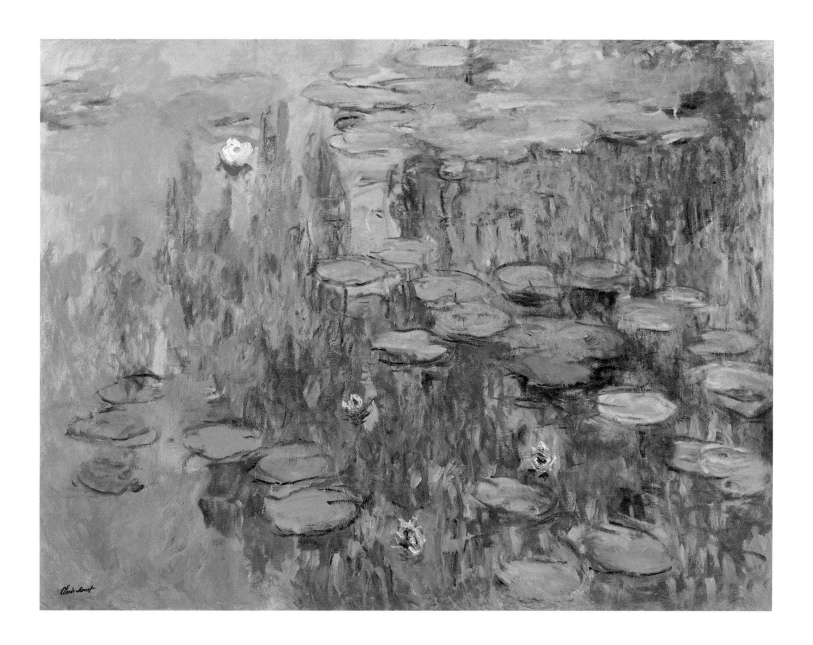

*Water Lilies. Ca 1918–21*

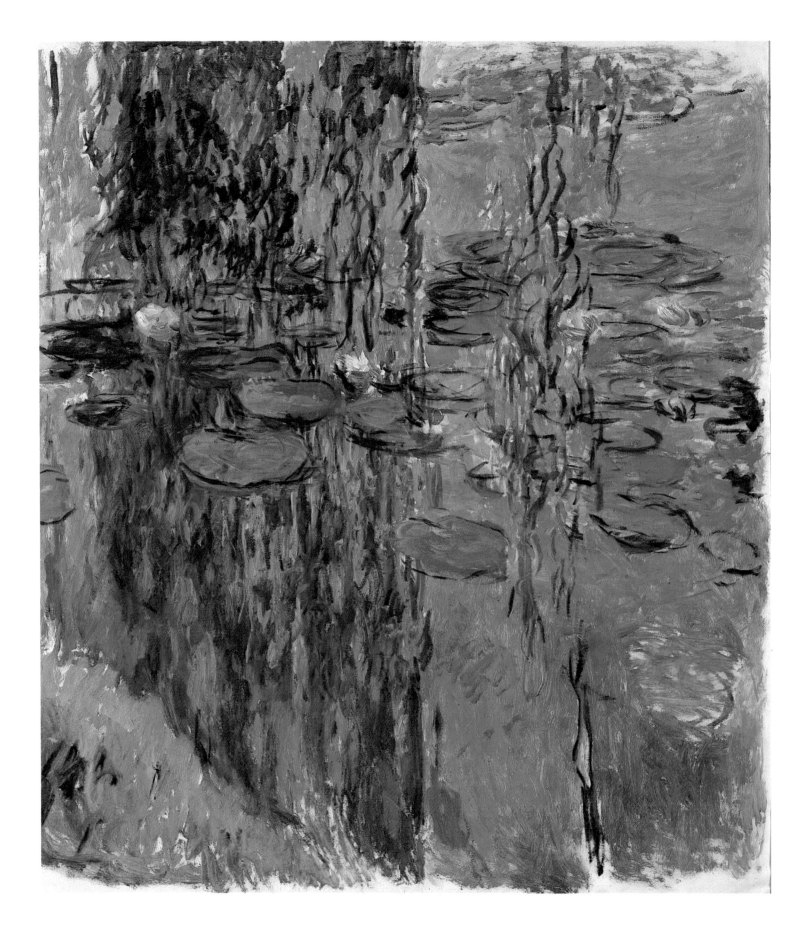

*Water Lilies. Ca 1918–25*

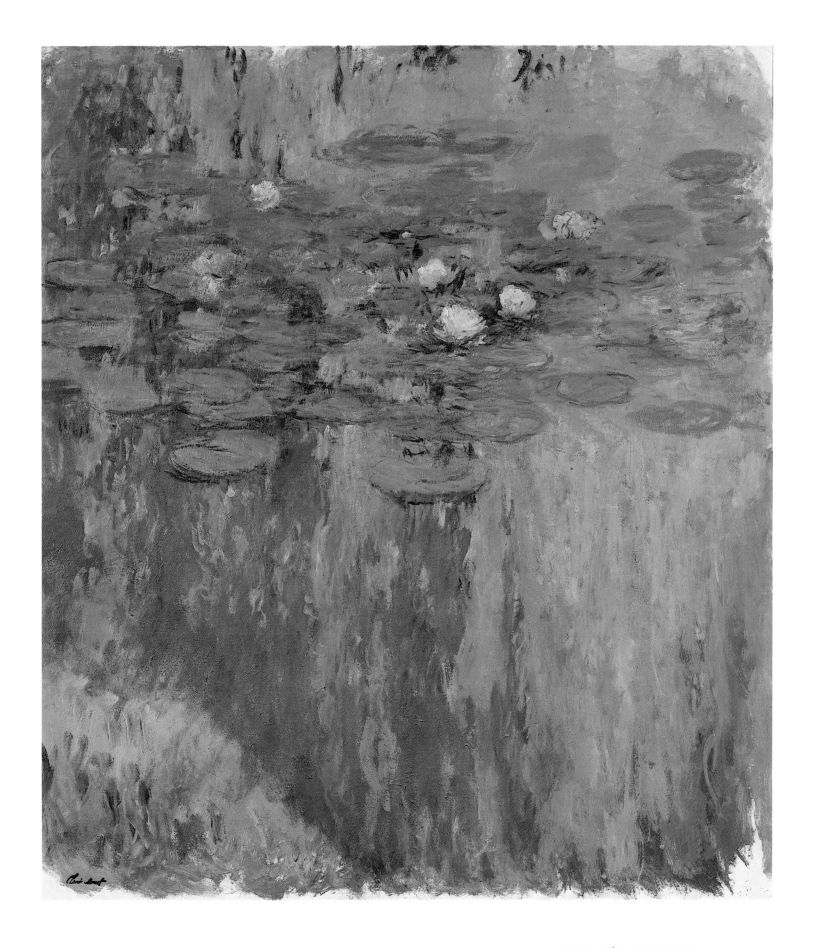

*Water Lilies. Ca 1918–25*

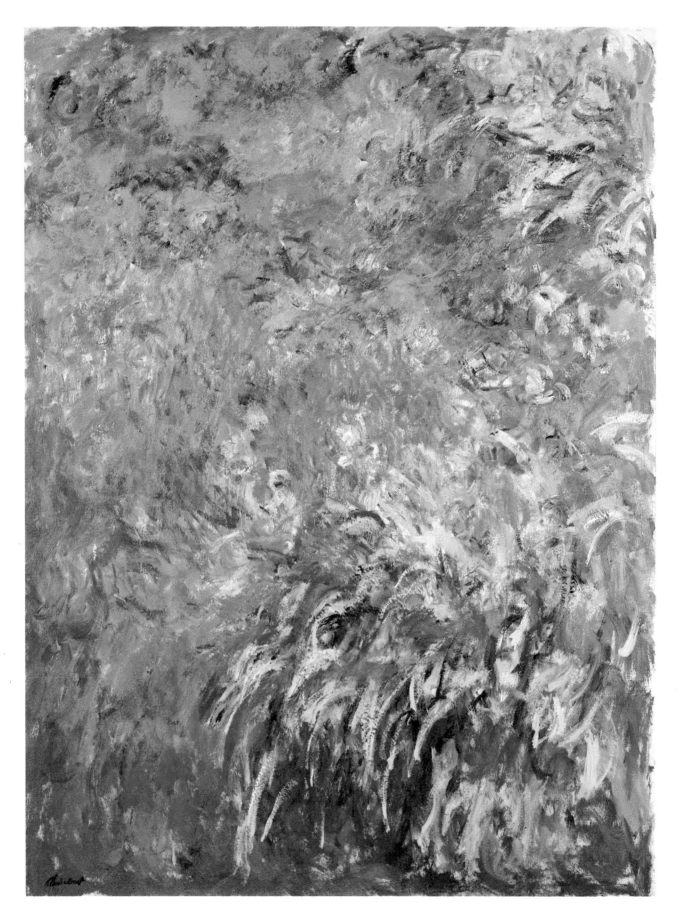

*Iris at the Water Lily Pond. Ca 1920–24*

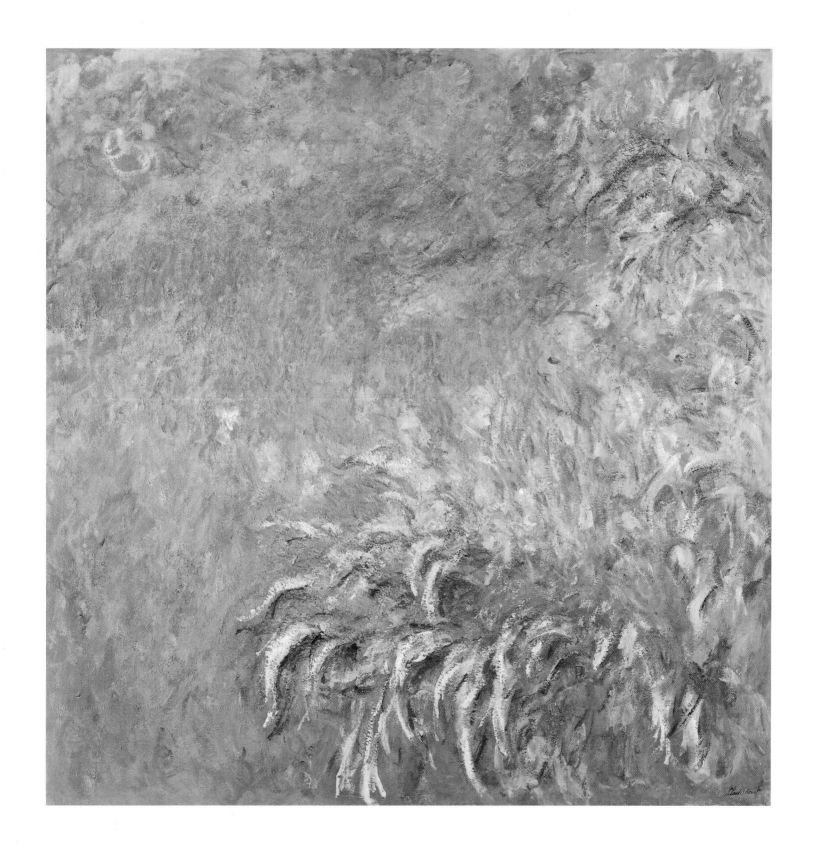

*Iris at the Water Lily Pond. Ca 1919–25*

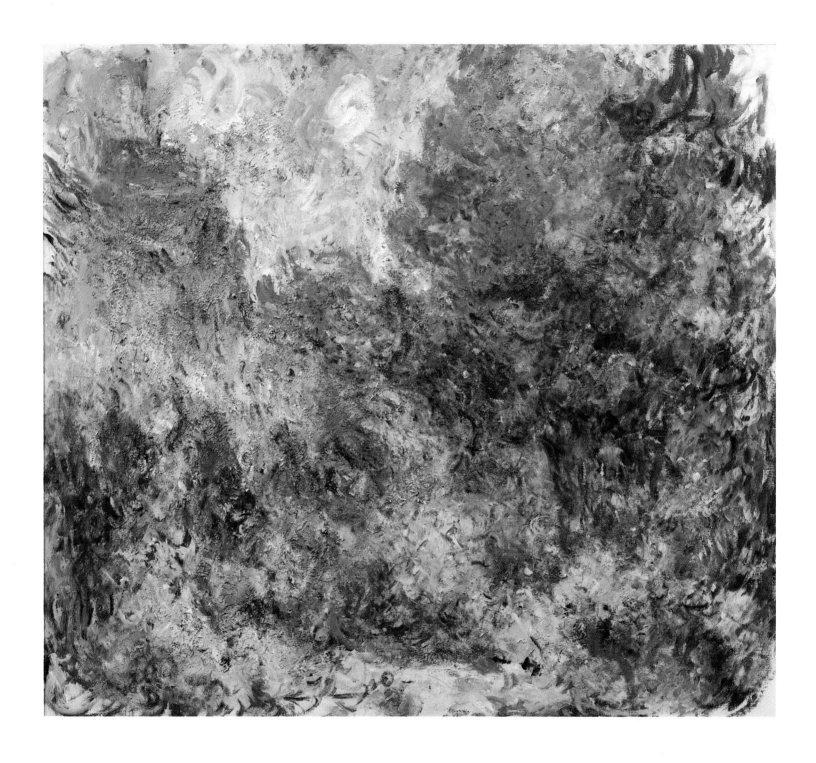

*Roses on the Garden Side of Monet's House at Giverny. Ca 1922*

Herbert Keller:

# The gardens of Giverny during Monet's lifetime and after reconstruction

After moving into the house and its grounds at Giverny, which was still rented for the first few years, Monet began to create flower beds and borders. He had to cultivate a fruit orchard that was completely overgrown with grass. Initially, he only had the help of his wife and children. Occasionally, he welcomed good advice from friends. But already Monet had some experience of gardens and, judging from some early photographs, he also had an eye for designing them.

*Colour plate p 20*

The picture he painted in his younger years, in 1866, of his Aunt Lécarde's garden in Sainte-Adresse, is an example of this: a garden room, formed by a framework of tree crowns and large shrubs, a well-maintained path, flanked by flower borders and standard roses. A place where particularly precious plants, regarded as 'noble' and occurring in nature in a simpler form or rarely at all, were united.

This image of the time shows a typical enclosed garden, a *hortus conclusus*. Its design and shape, including the choice of plants, were the result of human intervention. A garden of this type always has two components: on the one hand there are the plants, which have been improved in cultivation and which excel because of their habit and flower shape, colouring, size or the profusion of flowers they bear; on the other hand there are various garden styles and individually designed elements, such as water features, fountains, terracing, landscaping, direction of paths, pergolas, stairs or supporting walls and the materials chosen for these.

*Colour plate p 53*

Fifteen years this early garden image, in 1881, Monet painted his garden in Vétheuil, on the banks of the River Seine: it shows a sea of sunflowers, separated by a central path.

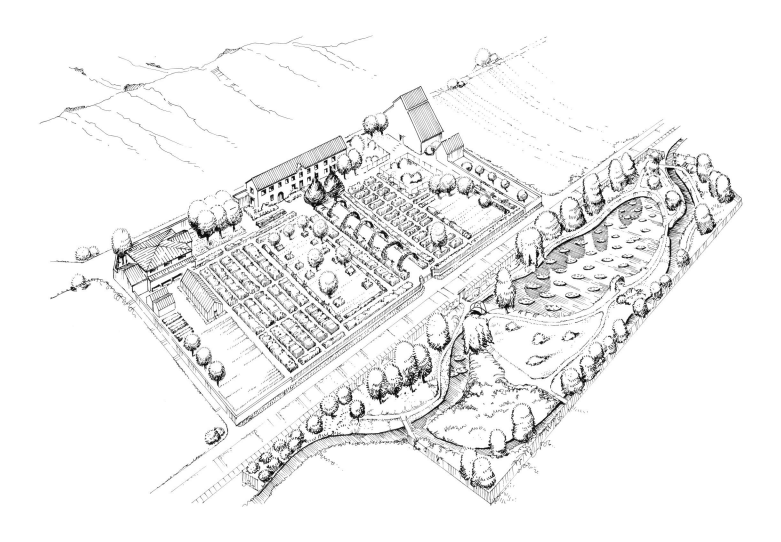

*Monet's gardens at Giverny shown in perspective*

Simply by sowing sunflower seeds in spring it is possible to create a fantastic effect in summer. Sunflowers with giant flower heads grow taller than a man in just a few months and last until late autumn. One has to assume that Monet knew of this rapid effect and recreated it in the garden. At least, in that summer he would have acquired such horticultural knowledge.

Later, when he had moved to Giverny, Monet was able to plan the garden in a systematic way and over a longer period of time. His design concept was intended for the longer term, which allowed him the time to gain experience. He obtained ornamental bushes and shrubs, perennials (herbaceous plants that flower over a number of years, often with a great abundance of flowers), as well as tubers such as dahlias and various sorts of iris, which he ordered from nursery catalogues.

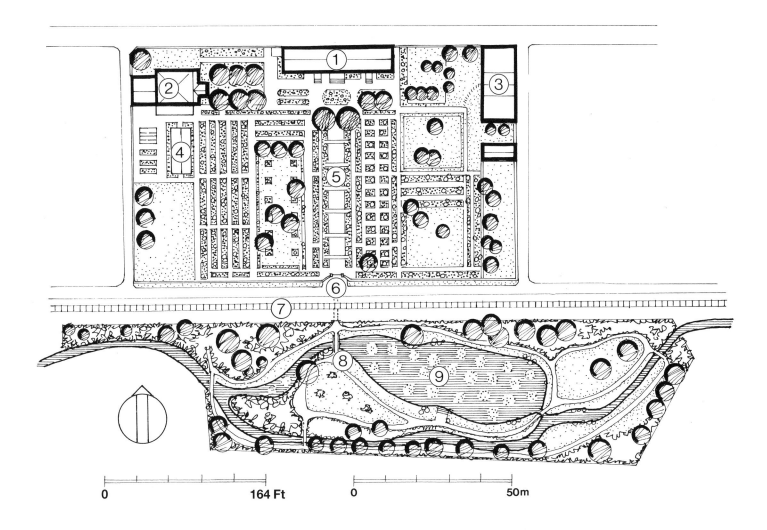

0    164 Ft    0    50m

Monet planted his acquisitions in parallel borders. According to photographic evidence and contemporary reports, he always grouped plants of the same species together, giving a strong show of colours and shapes.

As we can see from planting lists, which we shall look at in more detail below, he particularly favoured some of the 75 different species of plants that he included in his garden because of their flowers, colours or shapes. He used them repeatedly and gave the largest areas in the borders over to them. In spring, there were repeat showings of snowdrops, narcissi, primulas, aubretias and blue-violet lilies in several places under the pale pink blossoming clouds of the Japanese ornamental cherry trees. In summer, the garden was dominated by the pink and deep red of climbing roses, which Monet had used to cover the wide central path; in addition there were large numbers of campanula

*Plan of the gardens:*
*1 House and first studio*
*2 Second studio, accommodation*
*  for the gardeners*
*3 Third studio*
*4 Greenhouse*
*5 Central path with rose arches,*
*  at the end the two yews*
*6 Crossing to the water garden*
*7 Railway line*
*8 Japanese bridge*
*9 Water lily pond*

*Illus. p 101*

carpatica, the pale pink flowers of Japanese anemones and garden pinks as well as the strong red of dahlias, with the fine-petalled cactus dahlia a particular favourite of Monet's.

The relatively narrow strips of flowers made it fairly easy for the gardeners to look after the plants from both sides of the bed. Individual sections could be changed without affecting the remainder of the border planting. In this way Monet achieved strong areas of colour while maintaining a good overview, which was also useful from a practical, horticultural point of view. This way of arranging the flowerbeds may hark back to what he had seen or what was typical at the time. For the garden at Giverny it proved to be a sensible solution and it also made it possible to experiment with other, new types of plants, in smaller or larger areas, as necessary.

The individual flowerbeds had a width of 1.5 to 2 metres (5 to 6 feet) and were separated by paths. They were oriented to face south on a north-south sloping hill, to afford them the maximum benefit of the sun. In its upper areas the garden had a fairly steep incline of 10 per cent, which levelled out towards the bottom. The westerly group of flowerbeds consisted of 15 individual beds, ranging in length from 12 to 15 metres (about 40 to 50 feet).

*Illus. p 128*
The long central path, cloaked in roses, led from the shady seat under the old yews, which had been here for a long time, right down to the southerly garden gate, which formed the link with the future water garden. At a width of 5 metres (16 feet) this axial path was the generous centre point of the garden, enhanced by borders along its complete length on both sides, and emphasised by a series of rose arches, which formed a roof overhead. Immediately next to it – to the east – it was adjoined by a further 26 smaller flowerbeds, each with an area of about 5 square metres (54 square feet).

Between the beds and borders there still remained some connecting areas of lawn, which nevertheless in total occupied an area a third larger than that of all the planted flowerbeds put together.

*Illus. pp 12, 22, 30*
This is how the *Clos Normand*, the upper sloping garden locally known as *Le Pressoir*, appeared when it had almost been completed. Initially there was only one building, the residential house with its first-floor artist's studio, situated on the highest point of the garden. All the rooms in the house faced south, towards the garden.

Soon, the work in the garden could no longer be handled by the family alone. Gardeners were employed, including the talented Félix Breuil, who as head-gardener later had four or five assistants working for him. Residential quarters were set up for them in the north-west corner of the *Clos Normand*.
*Illus. p 39*
The building also contained a new second studio.

Immediately in front of it, to the south, was a nursery for young plants with cold frames and a greenhouse for overwintering tender plants such as agapanthus. A passion flower clambered over the walls here, too, next to the central heating that heated the greenhouse.

The working area for the gardeners and their assistants was not restricted to the sloping garden, for ten years after it was begun, in the spring of 1893, Monet acquired the meadows below the Clos Normand, an area of about 7,500 square metres (a little less than 1 3/4 acres), so that around 15,000 square metres (3 3/4 acres) had to be looked after in total.

The water supply from the little Ru stream made it possible to build a pond which could be flooded and closed off at will with the help of a lock; this also allowed Monet to regulate the rate of flow as he desired. In this way he created the ideal conditions for water lilies (nymphaea), as was to be become obvious; for, after only a few years, they were growing luxuriously and continued to do so up to Monet's death in 1926.

With this water garden, the style of the garden changed entirely, as we can see just by looking at the plan of the garden layout. The sloping garden, with all its overflowing abundance of plants and colours, was dominated by an orderly symmetry, the advantages of which we have already described. Here, plants that had been chosen for their flowers and shapes were combined to produce colour harmonies.

*Illus. p 145*

The concept of the water garden is an overall theme, dominated by the water area around which it is laid out. It was too crowded to be a classic 'landscape garden', too small in area and too rich in plants. But when Monet constructed the pond and designed its embankments, he had very different ideas and objectives in mind. Although conceived as a unit, the water garden was deliberately planned to consist of individual themes, lined up in canvas sizes, as shown by Monet's paintings; for example the numerous versions of groupings on the banks and the tufts of water lilies.

*Illus. p 90/91*

For Monet, the question of creating a particular style of garden was obviously of secondary importance, although at the time aesthetic questions such as the change from strict architectural lines to free landscape shapes was heavily debated in horticultural circles.

The garden fed by the Ru had a different character from the *Clos Normand*, not only in its design. The large, dominant water area created a different plant habitat, too. Here, water and marginal vegetation was allowed to and intended to thrive. We have to remember in this context that, at the time, many fewer plant varieties were commercially available for gardening purposes, and those that were available had on the whole only recently been imported from other

countries. Often such imported plants were still in their wild form, as found in their native habitats, unlike today, where cultivars are virtually the only ones available, albeit in a vast number of varieties.

For the time, the 75 or so species of plants that Monet grew in his garden were a considerable number, but of course this is not comparable with today, where for each of these species there are at least one or two dozen varieties of different colours and sizes available. (Our proprietary catalogues of perennials list, for example, 40 different species and varieties of bellflower [campanula] and about 80 varieties of iris.)

Again – and especially – in the water garden we see Monet's preference for particular plant varieties. He rather indulged his affection for certain plants and settled a large number of water lilies (nymphaea) of any variety that was available to him in the water, as long as they were able to grow there. Soon the entire pond was covered with water lily plants neatly enclosed in their own circles of leaves.

As these leaf carpets grew, resting on the water with their noble, cupped petals rising from them, Monet's intentions were realised. The quality of the water, the correct depth and the right water temperature are important for growing water lilies successfully and all these conditions were met at Giverny, or could be changed to suit as necessary. The newly dug pond had no vegetation of its own, as would have been the case with a natural pond. Thus, water weeds could be fought from the start and a living space for the water lilies was guaranteed.

With his constant interventions, Monet subjugated the 'pond nature'. He had all alien elements assiduously removed from the water's surface, which destroyed any plant rivalry that would have been unavoidable in nature. Into the pond's margins he planted marginal and bog plants, irises, grasses, bamboos and weeping willows, their branches trailing down over the water. The weeping

Illus. pp 112, 113

willow, with its expressive shape and habit, had only been discovered in France some 65 years previously, and was still a novelty given the age that trees generally reach.

Monet balanced the plants that hung over the water and were reflected in it with those that emerged from it, paying attention to profusion and colour as can be seen in the wisteria-cloaked arched bridge.

The trees, which included poplars and ash as well as the willows, allowed herbaceous plants and ornamental shrubs to flourish in humidity and partial

Illus. p 93

shade; they created especially happy conditions for Solomon's seal, pampas grass and bamboos, as well as irises, peonies, azaleas and rhododendrons. A much-admired individual plant was the fan leaf tree (ginkgo biloba), a

coniferous plant whose 'needles' look exactly like leaves. (It had been introduced from the Far East, where it served as a temple tree, at the beginning of the 18th century.)

Occasionally, fashionable novelties were welcomed at Giverny, if a desired effect could be created or an important purpose could be served. So it was, for example, with the iron arches for the climbing roses and the arched Japanese bridge, which permitted a view through to the water surface a long way beyond. Monet did not mind paying if he could achieve the right effect. He was not, however, interested in grottoes or similarly playful garden features that were popular at the time.

*Illus. pp 122, 128*

In his choice of plants Monet often opted for some unusual varieties, for example the weeping willow, which was at the time still unknown in the Seine Valley. But he found its trailing habit uniquely expressive, which made it an irreplaceable item in his garden.

Some years ago, the gardens of Giverny were restored and set up to take a large number of visitors, who today, when the weather is clement, stream into the gardens to take over the quiet resting places of the 'old man'.

A garden, unlike a building, is a growing and living thing. The façade and interior of a building can be reconstructed as they were at a particular time or over a period of time.

The story of the evolution of the gardens at Giverny, however, shows a continuous development. Monet, the driving force, had them enlarged, renewed and transformed for 40 years. Over this period more and more elements were gradually added to the planting. Other things also changed, which affected the garden rather less; for instance, the construction of the third, large studio between 1914 and 1916.

The railway line that ran between the sloping garden and the water garden was taken up. Later a wide road was built in its place, which is now heavily used by through traffic. The division of the garden into two parts has thus become rather more obvious than it would have been at the time, and today they are linked by a pedestrian tunnel underneath the road – a sensible measure taken for visitors' safety.

The view through the rose-covered axial path to the arched bridge can no longer be seen. It used to be the direct link between the house and the water garden, albeit interrupted by garden gates.

In itself, the almost year-round flowering made Monet's garden a very high-maintenance venture. Since this ever-changing profusion of flowers is an

important characteristic, however, it was essential to preserve it in the reconstruction. The gardens need constant care. If one considers the mostly manual effort that is involved in its upkeep, one has to pay one's respects to those who initiated the reconstruction.

Giverny has successfully been re-formed so that today's visitors are transported back to a garden at the turn of the 20th century, to Monet's garden. This is what gives this refuge its special atmosphere.

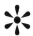

'If one lives in harmony with the appearance of things, one cannot be far from reality – or at least from what we can know of it. Your mistake lies in wanting to reduce the world to your own measurements, whereas if you widened your knowledge of things you would also widen your self-awareness.'

*Monet's last summer, 1926. Collection Mme Verneiges*

# Plants in the garden at Giverny during Monet's time

*The following list is based on a plant inventory made by Jean-Pierre Hoschedé, Monet's stepson, which is available in English. It was compiled for hobby gardeners and amateurs, which means that some of the species have not been named, because they can no longer be ascertained with any degree of accuracy. The preceding letters are used to denote the main flowering season, leaf colour, ornamental fruits and winter foliage: Sp = Spring, S = Summer, A = Autumn (flowering season); FC = plants with attractive leaf coloration; OF = plants bearing ornamental fruits; E = evergreen plants.*

| | English name | Botanical name |
|---|---|---|
| | *Trees and shrubs* | |
| | Alder | Alnus glutinosa |
| | Ash | Fraxinus excelsior |
| Sp/FC | Barberry | Berberis vulgaris |
| FC | Ginkgo | Ginkgo biloba |
| E | Holly | Ilex aquifolium |
| Sp | Horse chestnut | Aesculus hippocastanum |
| S | Hydrangea | Hydrangea |
| Sp/OF | Japanese apple | e.g. Malus sargentii |
| Sp | Japanese cherry | e.g. Prunus serrulata |
| FC | Japanese maple | Acer palmatum |
| Sp/OF | Japanese quince | Chaenomeles japonica |
| Sp | Lilac | Syringa chinensis |
| | Lime | e.g. Tilia cordata |
| | Poplar | Populus alba |
| | Raspberry | Rubus idaeus |
| Sp/E | Rhododendron | Rhododendron |
| S | Standard Rose | Rosa |
| | Sycamore | Acer pseudoplatanus |
| S | Tamarisk | Tamarix |
| S | Viburnum | Viburnum |
| | Weeping willow | Salix alba tristis |
| A | Winter jasmine | Jasminum nudiflorum |
| E | Yew | Taxus baccata |
| | | |
| | *Climbers and ramblers* | |
| Sp | Clematis | Clematis |
| S | Climbing rose | Rosa |
| | Passion flower | Passiflora |
| FC | Virginia creeper | Parthenocissus quinquefolia |
| Sp | Wisteria | Wisteria sinensis |

*Herbaceous perennials, bulbs and tubers; grasses*

| | | |
|---|---|---|
| S | African lily | Agapanthus africanus |
| A | Aster | Aster |
| Sp | Aubrietia | Aubrietia |
| FC | Bamboo, black bamboo | Arundinaria, Phyllostachys nigra |
| S/A | Blue thistle | Eryngium |
| Sp | Campanula carpatica | Campanula carpatica |
| Sp | Campanula | Campanula |
| S | Canna | Canna |
| A | Christmas rose | Helleborus niger |
| S | Columbine | Aquilegia vulgaris |
| S | Cone flower | Rudbeckia |
| Sp | Crocus | Crocus |
| A | Dahlia | Dahlia |
| Sp | Double daisy | Bellis perennis |
| S | Dead man's finger | Lamium |
| S | Delphinium | Delphinium |
| Sp | Doronicum | Doronicum |
| | Fern | e.g. Asplenium, Nephrolepis |
| S | Foxglove | Digitalis purpurea |
| S | Gladiolus | Gladiolus |
| S | Golden rod | Solidago |
| S | Heliopsis | e.g. Heliopsis scabra |
| Sp/S | Iris germanica, Dutch iris | Iris germanica |
| S | Japanese anemone | Anemone japonica |
| S | Leopard plant | Ligularia |
| S | Marigold | Tagetes patula |
| A | Monk's hood | Aconitum napellus |
| S | Morning glory | Ipomea |
| S | Mullein | Verbascum nigrum |
| Sp | Narcissus | Narcissus |
| S | Nasturtium | Tropaeolum majus |
| S | Oriental poppy | Papaver orientalis |
| FC | Pampas grass | Cortaderia selloana |
| Sp | Pansy | Viola tricolor |
| S | Pelargonium | Geranium |
| Sp | Peony | Paeonia |
| Sp/FC | Petasites | Petasites |
| S | Pink | Dianthus |
| Sp | Primula | Primula |
| S | Sage | Salvia |
| S | Snapdragon | Antirrhinum majus |
| Sp | Snowdrop | Galanthus nivalis |
| Sp/S | Solomon's seal | Polygonatum commutatum |
| S | St John's wort | Hypericum |
| S | Sunflower | Helianthus |
| S | Sweet pea | Lathyrus oderatus |
| Sp | Tulip | Tulipa |
| S | Viola cornuta | Viola cornuta |
| S | Water lily | Nymphaea alba |
| S | Willow herb | Epilobium |

# Selected bibliography

Bjork, Christina: Le Jardin de Monet, 2000
Duret, Théodore: Die Impressionisten, Berlin 1909
Geffroy, Gustave: Claude Monet, Sa vie, son temps, son oeuvre, Paris 1922
Hoschedé, Jean-Pierre: Claude Monet, ce mal connu – Intimité familiale d'un demisiècle à
    Giverny de 1883–1926, Geneva 1960
Joyes, Claire / Toulgouat, Jean-Marie / Gordon, Robert / Forge, Andrew: Monet at Giverny,
    London 1975
Keller, Horst: Die Kunst der französischen Impresisonisten, Freiburg im Breisgau 1975
Russell, Vivian: Monet's Garden, London 1995
Seitz, William C: Claude Monet, Cologne 1979
Spate, Virginia: Claude Monet: the Colour of Time, 2001
Tucker, Paul Hayes: Claude Monet: Life and Art, Yale 1997

Monet's Years in Giverny: Beyond Impressionism, exhibition catalogue, The Metropolitan
    Museum of Art, New York 1978
Hommage à Claude Monet (1840–1926), exhibition catalogue, Grand Palais, Paris 1980

Flaubert, Gustave: Madame Bovary, Oxford 1998

Keble-Martin, W.: The Concise British Flora in Colour, London 1976
Royal Horticultural Society Encyclopedia of Plants and Flowers, London 1999
The Reader's Digest New Encyclopedia of Garden Plants & Flowers, London 1997

# List of colour plates

62 | *A Bend in the Epte near Giverny. 1888*
Détour de l'Epte près de Giverny
Oil on canvas, 74 x 92.7 cm (29 1/8 x 36 1/2 in)
Sign., date br: Claude Monet 88
Philadelphia, The Museum of Art, The Williams L. Elkins Collection

64 | *Poplars. 1891*
Les peupliers (Les quatre arbres)
Oil on canvas, 81.9 x 81.6 cm (32 1/4 x 32 1/8 in)
Sig., date bl: Claude Monet 91
New York, The Metropolitan Museum of Art, The H.O. Havemeyer
Collection, Bequest of Mrs H. O. Havemeyer, 1929. (29.100.110)
Photograph © 1996 The Metropolitan Museum of Art

65 | *Poplars. 1891*
Les peuliers
Oil on canvas, 92.1 x 73.7 cm (36 1/4 x 29 in)
Sign., date br: Claude Monet 91
Philadelphia, The Museum of Art, Donation Chester Dale

66 | *Poplars on the Epte. 1890*
Les peuliers au bord de l'Epte
Oil on canvas, 92.4 x 73.7 cm (36 3/8 x 29 in)
Sign., date br: Claude Monet 90
London, The Tate Gallery

68 | *Haystacks in the Snow. 1891*
Meules dans la neige
Oil on canvas, 65.4 x 92.1 cm (25 3/4 x 36 1/4 in)
Sign., date bl: Claude Monet 91
New York, The Metropolitan Museum of Art, The H. O. Havemeyer
Collection, Bequest of Mrs H. O. Havemeyer, 1929. (29.100.109)
Photograph © 1996 The Metropolitan Museum of Art

69 | *Haystacks at Sunset. 1891*
Meules en soleil couchant
Oil on canvas, 73.3 x 92.6 cm (28 7/8 x 36 1/2 in)
Sign., date bl: Claude Monet 91
Boston, The Museum of Fine Arts, Juliana Cheney Edwards Collection, 25.112.

71 | *Haystacks in a Field. 1893*
Meules dans le champ
Oil on canvas, 66 x 101.6 cm (26 x 40 in)
Sign., date bl: Claude Monet 93
Springfield/Mass., The Museum of Fine Arts, The James Philip Gray Collection

74 | *Morning on the Seine near Giverney. 1897*
Le matin à la Seine près de Giverney
Oil on canvas, 81.6 x 93 cm (32 1/4 x 36 5/8 in)
Sign., date bl: Claude Monet 97
New York, The Metropolitan Museum of Art, Bequest of Julia W. Emmons, 1956. (56.135.4)
Photograph © 1996 The Metropolitan Museum of Art

134 | *Water Lilies. 1903*
Nymphéas
Oil on canvas, 81.3 x 101.6 cm (32 x 40 in)
Sign., date bl: Claude Monet 1903
Dayton/Ohio, The Art Institue, Donation Joseph Rubin

135 | *Water Lilies. Water Landscape. 1905*
Nymphéas. Passsage d'eau
Oil on canvas, 89.5 x 100.3 cm (35 ¼ x 39 ½ in)
Sign., bl: Claude Monet, French (1840–1926)
Boston, The Museum of Fine Arts, Donation Edward Jackson Holmes, 39.804.

136 | *Water Lilies. 1907*
Nymphéas
Oil on canvas, 81 x 92.1 cm (31 ⅞ x 36 ¼ in)
Sign., date br: Claude Monet 1907
Hartford, Wadsworth Atheneum, Estate Anne Parrish Titzell

137 | *Water Lilies. Ca 1918–21*
Nymphéas
Oil on canvas, 140 x 185 cm (55 ⅛ x 72 ⅞ in)
Sign., date bl: Claude Monet
Munich, Bayerische Staatsgemälde-Sammlungen, Neue Pinakothek

138 | *Water Lilies. Ca 1918–25*
Nymphéas
Oil on canvas, 200 x 180 cm (78 ¾ x 70 ⅞ in)
Unsigned
Paris, Musée Marmottan

139 | *Water Lilies. Ca 1918–25*
Nymphéas
Oil on canvas, 200 x 180 cm (78 ¾ x 70 ⅞ in)
Studio stamp bl: Claude Monet
Paris, Musée Marmottan

140 | *Iris at the Water Lily Pond. Ca 1920–24*
Iris au bord du bassin aux nymphéas
Oil on canvas, 199.4 x 150.5 cm (78 ½ x 59 ¼ in)
Studio stamp bl: Claude Monet
Richmond, The Virginia Museum of Fine Arts

141 | *Iris at the Water Lily Pond. Ca 1919–25*
Iris au bord du bassin aux nymphéas
Oil on canvas, 200.7 x 202.6 cm (79 x 79 ¾ in)
Studio stamp bl: Claude Monet
Chicago, The Art Institute Purchase Fund, 1956.1202
The Art Institute of Chicago. All rights reserved.

142 | *Roses on the Garend Side of Monet's House at Giverny. Ca 1922*
La maison de Giverny sous les roses
Oil on canvas, 89 x 100 cm (35 x 39 ⅜ in)
Unsigned
Paris, Musée Marmottan

# List of illustrations

# Quotations
*(For bibliographical details see selected bibliography p 154)*

p 2 ('The only thing in the world that interests me are my painting and my flowers'):
   Hommage à Claude Monet, p 13f
pp 28, 60: A visit to Giverny, pp 10, 3
pp 76, 84: Claire Joyes et al., Monet at Giverny, pp 10, 37
p 48: Monet's Years at Giverny, p 18
p 71: Maurice Sérullaz (ed), Lexikon des Impressionismus, Gütersloh, undated, sv "Claude Monet'
p 150: William C. Seitz, p 46